Norman Sanders

Photographic Tone Control

Morgan & Morgan
Dobbs Ferry, New York

Morgan & Morgan, Inc.
Publishers
145 Palisade Street
Dobbs Ferry, New York 10522

International Standard Book
Number 0-87100-117-9
Library of Congress Catalog Card
Number 77-83265
Printed in U.S.A. by
Morgan Press, Inc.

Book Design: Hoi Ling Chu
Illustrations: Benjamin Perez

Contents

This book is dedicated to Jo
my wife and very best friend

Acknowledgments

I am grateful to my children, Peter, Jane and Andy, to my students and to Brad Hess and Linc Hanson for their advice and encouragement during the months this presentation of the Photographic Tone Control System was in progress.

And I am indebted far beyond words of acknowledgement to the people whose talent and painstaking labor are reflected on every page—to Hoi Ling Chu, my friend, critic and the designer of the book; to Ben Perez, my former student, for the illustrations; to Hollis Todd for his perceptive and thorough analysis of the manuscript; and to my editor, Gladys Frank, for organizing and shaping the text.

This is their book as well as mine.

Preface

In the gay nineties, photography was easy. First, you bought a Kodak from George Eastman for $25.00. The camera was as big as a brick and weighed a couple of pounds. It had a fixed focus lens (everything from eight feet to infinity was sharp) and one shutter speed (aptly described as "instantaneous"). Inside was enough film for one hundred circular pictures, each one about two and a half inches in diameter.

After shooting the frames, you returned the camera to Eastman. At the factory, the film was removed and developed; contact prints were made and mounted. Then your camera was reloaded for one hundred more shots and returned to you. All for $10.00. Eastman's method, complete with the slogan, "You press the button, we do the rest," took the math and mess out of photography, and left in the magic. Unless you were shooting from a moving trolley on a cloudy day, you could expect some swell snapshots. What more could anyone want? In those good old days, for most people, the novelty of having permanent photographic images was exciting enough; print quality wasn't all that important. Neither was it all that controllable.

Those good old days are long since gone. Photography has matured to a creative and exacting craft, not only in terms of the photographer's statement, but also in regard to the technical quality of the final print. Point of view—the photographic statement—certainly warrants considerable study, as every serious photographer knows. There are a number of excellent books devoted to this subject.

This book, however, is concerned with the physical qualities of photography, or more specifically, with the problems and techniques of controlling tone. Tone control allows you to produce the print you have in mind, with highlights that are crisp but not featureless, well separated and specifically placed middletone values, and deep, detailed shadows.

The system proposed here cuts through a welter of trial and error, first, by giving you control over the density range of your negative, and then, by relating this control to your subject and your print-making. Exposure and development information is provided by the system to assure precise results and at the same time, to permit creative latitude in planning the scale of tones in the finished print.

There are, of course, occasions when a particular photographic statement is best served by burned out highlights or weak shadows. Once you have the ability to realign tone values to produce a full-range print, you can apply the same system—modified intentionally—when you choose to change tone placement or tonal range.

Your first task in mastering this system is to overcome the conditioning generated by automation. Technical sophistication has resulted in so many photographic procedures being labelled "automatic," that it is easy to assume fine print quality to be automatic, too. The implication is that proper film exposure, negative development and print making are mechanical chores, to be tolerated only until a new set-it-and-forget-it machine is invented that will do it all automatically. Maybe.

In the meantime, you must, every time you encounter the word automatic, remember to link it to its source and goal: the law of averages. Each of your materials is designed to be used within some sort of "average" framework, as in: average scene luminance range, average

subject, average film development time, average enlarger, average print.

If your photographic goals, your subject matter, your materials or your working conditions differ from the average upon which the instruction and data sheets are based, you must devise your own methods and standards. A photographic tone control system shows you how to do that. You do it with precision, with certainty, with freedom to choose a result and get it.

There are several approaches to the objective of controlling tonal scale from the moment the scene is photographed to the moment you see it in your print.

The goal of all these approaches is the same: controlled application of the variables in the photographic process to capture a particular quality in the finished print. In practice, however, the system described in this book provides the most practical data with the least expense of time, effort, and materials.

Photographic tone control is the shortest route between the image you visualize and the one you produce. With it, you will produce prints that satisfy you. Without photographic tone control, when conditions vary from the film or developer manufacturer's chosen average, you may be forced into long darkroom hours dodging and burning-in on many different contrast grades of paper, in one desperate salvage attempt after another.

To produce the print you have in mind precisely as you envision it, requires data from your own equipment, material and work habits. You will have to run some tests. Then the system is yours.

Chapter 1
Why is a Tone Control
System Necessary

Every photographer has experienced the disappointment of seeing a potentially great photograph reduce itself to a mediocre, or even disastrous, print. What adds to the frustration is an inability to pinpoint what went wrong, to ascertain at what stage the desired quality or interpretation slipped away. Clearly, it is not enough to be aware of discrete measurable factors in photography; an accurate way must be found to orchestrate these interrelated and variable elements.

Three fundamental photographic measurements are involved. The first deals with light and includes consideration of both the light source and the gradations of its reflection from objects in the scene. The second denotes the intensity with which these gradations of light—these tones in the scene—are recorded on the negative. The third assesses the scope and gradation capability of the photographic paper. It is upon the precise correlation of these three measurements that the successful photographic print depends.

The need for an accurate tone control system becomes more apparent with a brief review of these factors:
— Scene luminance range (sometimes called subject contrast)
— Film negative density range
— Photographic paper response range (also called scale index)

● Scene Luminance Range is the relationship between the light levels, as measured with your meter, of what you consider the brightest and darkest important areas in the scene.

A conventional exposure meter is one that is aimed at the subject from the camera position. Since such a meter usually has an angle of acceptance of 30° or more, reading specific areas of a scene requires that you move in as close to the object as possible, along the lens-to-object axis, being careful not to allow the meter to cast its shadow on the sample being read.

● **Luminance** is the light available from the scene. Your meter measures it.

Brightness is a subjective visual impression. No meter measures it.

For a fuller explanation of these terms and others used throughout the text, refer to the Glossary at the back of the book.

The angle of acceptance of a conventional exposure meter is at least 30 degrees. To read the light level of a specific area, you must move in close.

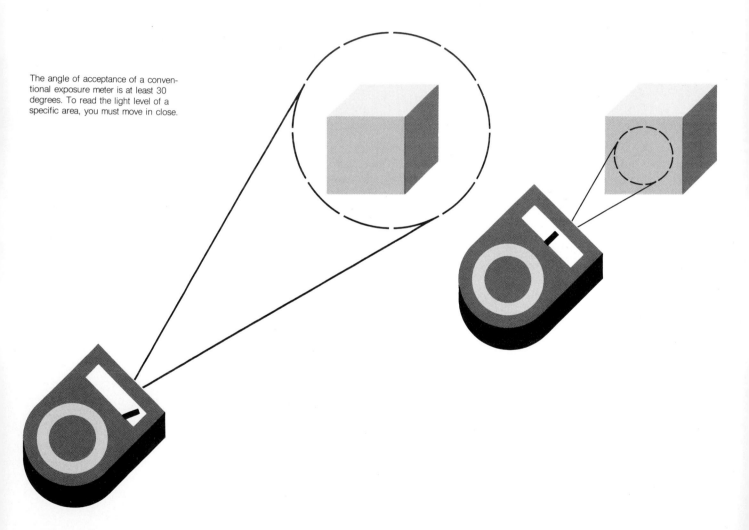

When activated, the meter needle points to one of about 20 numbers on the luminance level dial. The numbers, in themselves, usually mean little. The reading must be transferred to aperture and shutter-speed dials to convert it to actual camera settings.

But those scale numbers alone have a special usefulness; they are excellent for calculating luminance ranges. If, for example, your meter registered 12 when aimed at the scene highlight, and registered 8 when aimed at the scene's darkest shadow area, the scene luminance range would be 4.

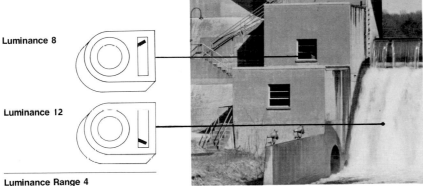

Luminance 8

Luminance 12

Luminance Range 4

To avoid confusion between scene luminance range—an important component of tone control—and two terms used in other contexts to interpret light meter readings, we will digress briefly for definitions.

1. *Luminance ratio* expresses the relationship between the light available from one area in a scene and that from another area, as read by your meter. Each number on the light meter dial indicates an amount of light that is twice its next lower number.

For example: If you were to aim your meter at one area and the needle pointed to 8, then aim it at another area and the needle pointed to 9, it would indicate that "Area 9" is twice as luminant as "Area 8". Since each number is twice its predecessor, you might also work up a list such as this one:

9 is 2 times as luminant as 8 (luminance ratio 2:1)

10 is 4 times as luminant as 8 (luminance ratio 4:1)

11 is 8 times as luminant as 8 (luminance ratio 8:1)

12 is 16 times as luminant as 8 (luminance ratio 16:1)

Luminance ratio is based on readings that include both subject reflectance and illumination. Lighting ratio, which will be defined next, is based on illumination alone.

2. *Lighting ratio* expresses the relationship between the light from the main source of illumination plus fill illumination, and light from the fill illumination alone. To calculate lighting ratio, the measurements to be compared must be from the same object (usually a Kodak Neutral Test Card). Measurement of an outdoor lighting ratio can be made by taking a meter reading from the gray card held at the subject position and facing halfway between the camera and the sun (main and fill light); then comparing that reading to one made with the card aimed at the camera, shaded from the direct sun, but not from the sky light (fill light).

A one number difference between main plus fill, and fill light alone is 2:1 lighting ratio

A two number difference between main plus fill, and fill light alone is 4:1 lighting ratio

A three number difference between main plus fill, and fill light alone is 8:1 lighting ratio

Lighting ratios are characteristically less than luminance ratios because lighting ratios do not take into account actual subject differences in reflectance (white shirt, black coat, for example), as luminance ratios do. It is possible then, to have a lighting ratio of 8:1, and luminance ratio of 128:1.

For our purposes, instead of becoming involved with lighting ratios and luminance ratios, we will use the simpler reference of luminance range. This is the designation for the number of meter steps between the extremes of important highlight and shadow. By taking readings of different scenes, you will find that *luminance range is not the same in all scenes.* Some typical readings might be:

Location	Shadow	Highlight	Luminance Range
Slightly overcast outdoors	11	16	5
Clear outdoors	12	18	6
Living room including window	6	13	7
Bedroom	5	9	4

Furthermore, luminance range of a given scene is not constant (outdoors it may change from one moment to another). The next item to consider, therefore, is the effect of various scene ranges on negative density range.

Film Negative Density Range is the difference between the blackest and least blackened areas within the picture portion of your film negative. It is best found from measurements made with a densitometer, and we will get to that in Chapter 11. For the moment, a visual comparison is adequate.

If you were to meter and photograph an area (say, a house), when it was in shadow, and meter and photograph it again on the same roll of film when it was in sunlight, the negatives would look significantly different. The negative made in shadow (scene range of about 4 numbers) would seem flatter, and not as black in the highlights as the sunlit negative (scene range of 6 numbers or so). Since they were both shot on the same roll and processed using the same developer and development time, it is safe to assume that the difference in scene luminance ranges produced the recognizably different density ranges on the film. *The greater the scene luminance range, in general, the longer the film density range.*

Scene luminance ranges are not all alike. Since the negative density ranges they generate are not all alike either, the next factor to examine is the effect of different negative density ranges on a photographic paper.

A house photographed in shade might produce a film negative that looks like this.

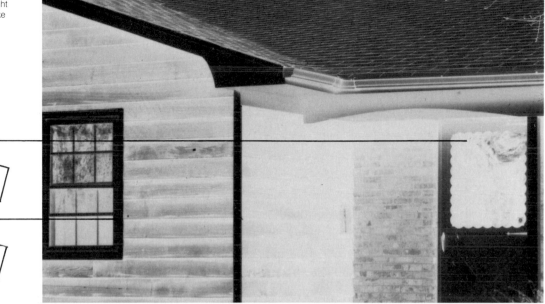

Shadow

Highlight

This is how the film negative might look if the exposure were made in sunlight. Note the longer density range in this negative as compared to the one above.

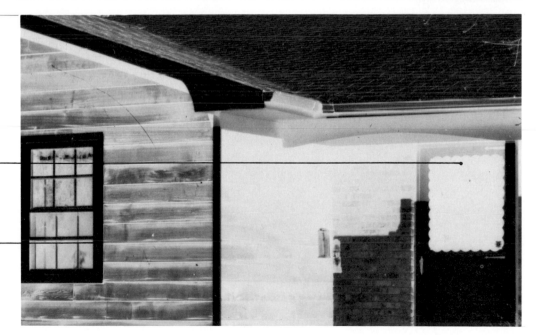

Shadow

Highlight

Photographic Paper Response Range denotes the precise range of film negative density to which the paper is responsive. Only a particular density range, when exposed onto a given grade of photographic paper, will produce the full scale of its tones in the print. Response range is fixed within the paper contrast grade, and cannot be materially altered by darkroom techniques. Proof of this is best demonstrated with a description of the following experiments.

Objective 1:
To determine whether enlarger exposure time has a significant effect on a photographic paper's response range.

A step tablet (a film negative tonal scale with even density difference step-offs) was placed in the negative carrier of the enlarger and three exposures made onto one sheet of photographic paper. The first exposure time was 5 seconds, the second was 10 seconds and the third was 20 seconds. Each exposure was made on a separate area of the print paper. Then the print was developed conventionally, transferred to the stop bath, the fix and the wash water. The dried print showed each test strip as a black area, a series of decreasing gray steps, then a white area.

Although a different series of consecutive tablet-steps was recorded with each different exposure, the *number* of steps recorded was the same in all cases. (The experiment was repeated, keeping exposure time constant, and changing enlarger lens openings in one-stop increments. The results were substantially the same.) The film negative density range to which a paper responds does not get significantly longer or shorter with a change in the amount of enlarger exposure.

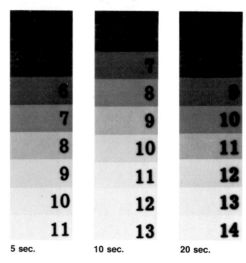

5 sec. 10 sec. 20 sec.

Objective 2:
To determine whether print development time has a significant effect on the paper's response range.

A common exposure of the step tablet was made on three separate pieces cut from one sheet of print paper, and each piece was developed for a different length of time (two, four and six minutes). Result: The prints showed no significant difference in the number of gray steps they recorded.

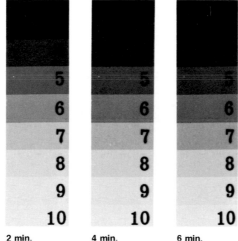

2 min. **4 min.** **6 min.**

What happens when negative density range doesn't match a paper's response range? If the negative range is not compatible with a photographic paper's ability to record it, the result could be one or
▲ more of the following (all unsatisfactory):

1. Negative density range too long for the paper's response range:
a. *When the highlights are printed properly,* the middle tones will be too dark, and the shadows will be without detail; just a heavy black mass. Unsatisfactory.
b. *When the shadows are printed properly,* the highlights will burn out. Unsatisfactory.

2. Negative density range too short for the paper's response range:
a. *When the highlights are printed properly,* the middle tones will be dull, and the shadows will seem weak and washed out. Unsatisfactory.
b. *When the shadows are printed properly,* the highlights will be dingy and the print will look dull and flat. Unsatisfactory.

Conclusion: Neither enlarger exposure time nor print development time significantly changes the photographic paper's ability to respond to differences in nega-
● tive density range.

Both Eastman Kodak and the Ilford Company advise against altering development time radically in an attempt to change the paper's response range. Sometimes, however, lengthened development can be used as an economy measure to try to save a print that has been slightly underexposed in the enlarging.

A specific contrast grade of paper has the ability to be correctly matched to one negative density range. Only one.

Often it makes sense to change from your normal paper contrast grade to one that is more compatible with the particular negative density range you want to print. At times, though, the negative density range can be so long that there is no low contrast paper available to handle it adequately. In addition, an unplanned for change in paper contrast grade may have an unwelcome effect on graininess (higher contrast papers tending to increase graininess), and on middle tone density and highlight or shadow detail.

There is a better way . . .

● There are some paper developers that do have the capacity to increase the reproducible negative range beyond that obtained with Dektol. Selectol-Soft is one such developer. But since its ability to alter contrast is small—about one contrast grade—it is not practical for our purposes.

▲ Examples of these effects appear on the following page.

When a negative's range is not compatible with the response range of a photographic paper, you may get results such as these.

Negative density range **too long** for the paper's response range. Highlights have been printed properly, but midtones and shadows were sacrificed.

Negative density range **too long** for the paper's response range. Shadows have been printed properly, but highlight values were lost.

Negative density range **too short** for the paper's response range. Highlights are all right; middletones are dull and shadows weak.

Negative density range **too short** for the paper's response range. Favoring strong shadows destroyed middletones and highlights.

You can control the range of tones in the negative so that it becomes compatible with the paper you print on. This does not imply that all your prints on a chosen paper will be visually similar despite variations in scene luminance range. Within a given negative density range is the potential for a variety of effects from high to low contrast, and for optimum rendering of widely differing scenes.

When your negative cannot be matched to a photographic paper, you may lose what you most wanted to capture in your print. A controlled negative, on the other hand, distills the scene into a printable range that preserves the effect of the scene and compromises only expendable variations.

The concept of controlling negative density range—limiting it on purpose—may be difficult to accept. But no photographic paper exists that can record, as a full scale print, the gamut of possible film density ranges.

The Photographic Tone Control System is concerned with determining the precise highlight to shadow density range your negative should have to be totally recorded on your regular photographic paper. It takes into account your darkroom methods, equipment and materials.

In addition, this system provides you with information that allows you to photograph a scene controlling both exposure and development to yield that precise negative density range.

Should you want an object to have a specific tone on the print, the system also provides precise exposure and development data correlated with the proper printmaking data to produce the tone value you designate.

Fundamental to the system is the conviction that uniformly excellent prints can best be achieved with planned negative densities and standardized printing methods. Variations in scene range are treated appropriately by studied variations in camera settings and film development times. This approach provides greater flexibility and far more predictable results than those attained by changing paper grades or print exposure and development times to accommodate "difficult" negatives.

Negative density range matches paper's response range. The result is a full range print with both highlight and shadow detail.

Chapter 2
Light Meters

In order to learn exactly how to adjust the scene range effect on the negative density range so that it will fit your paper choice, you will have to run a series of Tone Control Tests. It is a procedure that establishes the precise effect of your own film development chemistry, equipment and technique on negative density range.

We will get to the actual test procedures in Chapter 4 after we have talked about exposure meters, lens and shutter speed settings, and film characteristics. The test—and all tone control techniques—are predicated upon a practical knowledge of these photographic devices and materials.

Since the first concern in any tone control system is with light from specific objects and with scene luminance range, take a moment to familiarize yourself with a vital aspect of photoelectric meters:

The dials on the meter that correlate each light level number with shutter speed and lens opening settings are designed to do one specific job . . . to provide you with a negative that, with standardized printing methods, will produce a print with this medium gray tone:

This middle gray tone value is designated as 18% reflectance.

You can obtain a larger and more accurate sample than the one shown here by buying Kodak Neutral Test Cards from a photographic dealer. The cards are inexpensive and useful. When you get to the printmaking phase of the tone control system, you will need them for tone comparison.

To repeat: a conventional exposure meter reacts to the light that it receives in its total angle of view and converts it to film exposure information that, with standard printmaking, will reproduce the meter's angle of view as this 18% reflectance middle gray tone on your print.

We can illustrate this fact by applying it to three sample photographic subjects:

1. You aim the meter at a snowman and set your camera accordingly. The meter will, in effect, "think" it is being aimed at something that you want to print as middle-gray. The meter will provide data so that—unless you change your method of printing—your print will be produced with gray snow.

2. You take a close-up meter reading of a black cat. The meter will indicate the proper exposure for it to be reproduced as an 18% reflectance cat . . . a gray cat.

3. You move in with your meter and camera for a tightly framed image of a Caucasian face. (It is twice as luminant as an 18% reflectance card, and even more than that, sometimes.) The face will appear too dark in your print.

Three tries—three wrong exposures.

Is the meter in error? No.

The camera settings indicated on the light meter dial each time should have been followed *only* if you had played the game: aimed your light meter *only* at such subjects as you chose to reproduce as an 18% gray in your print.

The snowman needed a larger aperture or more time than the meter indicated, so that the white snow could be reproduced in highlight values; the cat needed a smaller aperture or less time than the meter indicated in order for a print to show the cat in shadow values; and the Caucasian face needed a larger aperture or more time for a lighter, more pleasing tonality.

To help condition yourself to use your meter for your choice of tone placement, instead of letting your meter use you to set your camera, try this: Walk through a couple of rooms with the Kodak Test Card and compare it to various objects in terms of the tone you would want each of them to be (in comparison to the gray card) in a photograph that showed only the object. Consider each in terms of whether you would want the print image to be lighter, the same value, or darker than the card. (We will discuss how much lighter or darker after we have run through the printmaking part of the system.) For example, you might want:

A. A plate of cheese and crackers to reproduce lighter than the 18% reflectance card
B. An old telephone . . . darker
C. Your schnauzer . . . about the same as the card
D. A top hat . . . darker
E. A glass of milk . . . lighter

Whether your subject is light or dark,
your meter provides data for an 18%
gray reproduction.

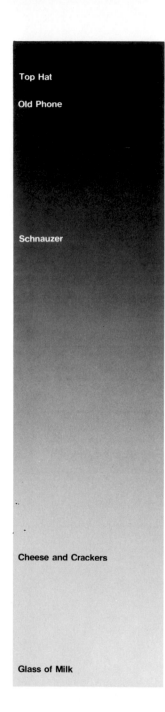

Top Hat

Old Phone

Schnauzer

Cheese and Crackers

Glass of Milk

Now: If a close-up meter reading were made of each of these objects, the camera set as the meter instructed, and a photograph made of each object, every one of them would be reproduced as an 18% gray *and four of the five would have been exposed incorrectly.* The reason: Your meter has been programmed to supply exposure information based on the expectation that the average tone within its angle of view will be the middle gray of your Test Card.

This exercise reduces your meter's capability to the simplest possible terms. Obviously, a meter reading from an isolated object (such as a snowman or a black cat) requires adjustment based on your own visual assessment of the subject.

What happens when you step back with your meter for a camera-position reading of a broader scene? Now the meter's angle of view encompasses a multiplicity of objects and a variety of illumination effects. The meter's response in this case, is to scramble the many light levels it receives, average them to a single reading, and direct a camera setting that will reproduce the average light level as an 18% reflectance tone.

Since virtually all photoelectric meters are keyed to the 18% reflectance print tone, the reasoning behind this programming bears some scrutiny. The effort seems to have been made to correlate the mid-value in an average scene with a medium gray print tone.

The customary explanation for assuming 18% reflectance to be the precise mid-value of a scene, is that whites such as snow reflect 81% of the light falling on them, and dark areas of a scene reflect only about 4%. Since the meter is programmed so that each number on the dial indicates twice as much light as its next lower number, the method of determining the mid-point between 4% and 81% reflectance would be to multiply the two extremes and then compute the square root of their product.

$$4\% \times 81\% = 324\%$$
$$\sqrt{324\%} = 18\% \text{ reflectance: the average}$$
Proof: $18 \times 18 = 324$

There is a tendency at this point, because the arithmetic is correct (the square root of 324 *is* 18), to accept the explanation as correct also. But a few minutes' work with a pocket calculator points up the following:

1. If the shadow reflectance of a scene is 5%
● instead of 4% (a minor gain) the highlights in the scene could be only about 65% to yield the same "average scene" 18% mid-point.

2. If the scene's shadow reflectance is 3%,
▲ instead of the 4% used in the formula, one would require more than a theoretically impossible 102% highlight reflectance, to provide an 18% mid-point.

Stated another way, a ±1% change in shadow reflectance must coincide with a substantial change in total scene range, in order to provide an 18% scene reflectance average.

In addition, beginning with the highlight end of the scene range, 81% reflectance as stated in the formula, *only* a 4% shadow reflectance would provide an 18% midpoint.

It is interesting to note that one of the most authoritative texts on the subject (*Exposure Manual,* Dunn and Wakefield) pegs average scene highlights at 66% and shadows at 1%. This would provide an average scene mid-tone, not of 18% reflectance, but 8%.

From this small exercise, and the fact that the average scene in temperate zones does not include snow and as a result the scene mid-point is usually less than 18% reflectance, it becomes evident that the oft quoted formula is not realistic. The theory that 18% reflectance is the precise mid-point of the average scene is just not convincing. But that is only part of the problem.

To go one step further: If you were to photograph a scene that did, in fact, have a range from 4% reflectance in the shadows to 81% in the highlights, could you then trust your averaging meter for appropriate exposure information? Not always.

A light meter does not arrive at its recommended exposure data by averaging only the extremes of highlight and shadow to find the scene mid-value as in the formula. It averages *all* the light levels it receives, and the *proportion of each scene tone* as well as its luminance enters the equation. Thus, when large masses of highlight or of shadow dominate the total scene, the average shifts away from the median—the midpoint between the extremes of scene value. It is important to distinguish between the average of the scene's light levels, which your meter reads, and the mid-point between highlight and shadow, which is often an appropriate area on which to place the 18% reflectance print tone. Occasionally they coincide, but if the largest mass of your scene is lighter or darker than the median tone (as in a landscape that includes a large sky area), the average luminance could be far different from the mid-value of the scene.

Remember: Light meters having a large angle of view are programmed to indicate the proper camera settings (f-stop and time) for an "average" scene. The meter manufacturers are saying in effect: "If the important separate object reflectances in the scene were homogenized, they would average as an 18% reflectance value, and that average would be halfway between the scene's highlight and shadow extremes." Few scenes are, in these terms, "average."

● 5% × 65% = 325%
 √325% = approximately 18%

▲ 3% × 103% = 309%
 √309% = nearly 18%

Once more: An exposure meter does not know what it is being aimed at. It receives a light level impulse and converts that information to instruct you to set your camera so that the average of the scene luminances will, with normal film development and a standard printing process, be reproduced on the print as an 18% gray tone—this value:

● If that isn't what you want on your print you will have to overrule the meter. And *that* is OK. Really it is.

Just how to determine correct camera settings will become clear when your tone control tests are completed. For the moment, what is required is a new perspective on the gray tone to which the meter is keyed, and an interpretation of its application. This 18% reflectance value is approximately the middle of the scale of grays of the Munsell Color System, a scale attainable on photographic papers.

Albert Munsell (1858–1918), an American painter, established a color reference system based on equal visual step-offs of tone. The axis of the system is a ten step gray scale. Step 5 is approximately 18% reflectance.

Specifically, 18% reflectance is step 4.9 on the Munsell scale, with a density of 0.74. The difference between 18%, the photography standard, and 19%, the Munsell standard, is insignificant.

Since the Munsell values are established in *equal visual steps of gray* (not equal density spans or reflectance spans) with the lightest and darkest tones approximating the lightest and darkest tones available in a photographic print, the scale is relevant and useful in print evaluation, as you will see graphically in Chapter 11. In the present context, emphasis is on the midpoint of this visual scale, since it coincides with an exposure meter's programming.

Although the 18% reflectance value is an unreliable reference when arbitrarily placed (by your meter) on the *average* of the scene luminances, it is a logical *print mid-tone* standard when its placement is controlled.

In Photographic Tone Control, that medium gray value is used as a constant frame of reference to which other tones and all photographic variables relate. With the system, once your test prints are made, your meter is read and camera settings determined with a tonal scale in mind. The meter becomes your servant rather than your master in the placement of the middle gray value, and tone alignment is based on your personal interpretation of the scene. The values you choose are recorded appropriately on the negative, thus minimizing the need for tone manipulation during the printmaking.

In correlating camera settings with print tones, your tests establish print-making standards which can remain fixed, except when you elect to alter them for special effects. This does not preclude the use of variable-contrast type papers with various filters or other techniques such as dodging and burning in, but it assigns these activities a creative rather than a corrective role.

Munsell Scale	Approximate Density	Approximate Reflectance
1 (Black)	1.93	1%
2	1.52	3%
3	1.19	6%
4	0.93	12%
5 (Middle Gray)	0.72	19%
6	0.53	30%
7	0.38	42%
8	0.24	58%
9	0.12	76%
10 (White)	0.00	100%

Chapter 3
Camera Settings
and Film

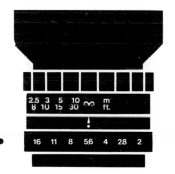

Lens Aperture Settings:
Just as the numbers on your luminance meter are spaced so that increasing numbers on the dial indicate a doubling in the light level reflected to the meter, each successive lens setting on your camera signifies the aperture is allowing twice as much light to pass through the lens and be gathered on the film in a given time period. The $2\times$ light admittance factor is indicated on your lens with a sequence of some of these numbers:

64	45	32	22	16	11	8
5.6	4.0	2.8	2.0	1.4	1.0	0.7

Other numbers, 6.3, 3.5, 1.8 for example, are not full steps.

The number designation for these lens openings—f-stops—run counter to the actual size of the aperture. The larger the f number, the *smaller* the opening. For example, f/16 is a smaller lens opening than f/8.

The reason is that f numbers, which relate to the diameter of the opening, are the denominators in a series of fractions: f/8 and f/16 actually denote an aperture diameter $\frac{1}{8}$ and $\frac{1}{16}$ of a given distance. Since $\frac{1}{8}$ of something is larger than $\frac{1}{16}$ of it, f/8 is a larger size aperture than f/16. That distance upon which the fraction is computed, is the focal length of the lens: the measurement from about the center of a normal lens to the film plane, when the camera is set at infinity.

$$\frac{\text{Diameter of Aperture}}{\text{Lens Focal Length}} = \frac{10\text{mm}}{80\text{mm}} = \frac{1}{8} = f/8$$

▲
$$\frac{\text{Diameter of Aperture}}{\text{Lens Focal Length}} = \frac{5\text{mm}}{80\text{mm}} = \frac{1}{16} = f/16$$

This implies, correctly, that as the focal lengths of lenses increase (80mm lens, 150mm lens) the same f-stop—say f/8—becomes a larger diameter of aperture in each case.

$$\frac{\text{Diameter of Aperture}}{\text{Lens Focal Length}} = \frac{10\text{mm}}{80\text{mm}} = \frac{1}{8} = f/8$$

$$\frac{\text{Diameter of Aperture}}{\text{Lens Focal Length}} = \frac{18.8\text{mm}}{150\text{mm}} = \frac{1}{8} = f/8$$

The beauty of this seemingly complicated system of aperture designation rather than actual measurement (say, in millimeters) is that at infinity focus and a given f-stop, the same light level falls on the film plane no matter what the lens focal length is. So, though the actual diameter of aperture measures differently, *the setting of f/8 on a 50mm, 80mm and on a 150mm lens provides the same level of light on the film plane.*

When the lens is focused at infinity, the lens-to-film distance equals the lens focal length.

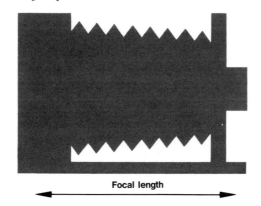

Focal length

Camera Shutter Speeds:

As the sequential exposure meter numbers indicate doubling luminance intervals, and sequential lens f-stops are spaced at doubling light-admitting intervals, so also, are shutter speeds repeatedly doubled—or approximately doubled—on most cameras. Some common progressions of speed settings are: $\frac{1}{1000}$ sec., $\frac{1}{500}$, $\frac{1}{250}$, $\frac{1}{125}$, $\frac{1}{60}$, $\frac{1}{30}$, $\frac{1}{15}$, etc.

For practical purposes $\frac{1}{60}$ of a second, while not exactly twice as long as $\frac{1}{125}$ of a second, can be considered a $2\times$ factor. ($\frac{1}{60}$ sec., rather than $\frac{1}{62.5}$ sec.—which is exactly double $\frac{1}{125}$ sec.—indicates additional exposure equivalent to only one twenty-fifth of a lens stop.)

When you run your Tone Control Exposure Test, you apply this very useful bit of "doubling data" in order to systematically reduce the amount of light, or systematically increase the amount of light falling on the film. Your one f-stop changes (or speed changes, if necessary) correlate exactly to one-number-of-luminance differences on your exposure meter. (One number less on the meter indicates half as much light; one lens opening smaller on your lens admits half as much light).

With an 80 mm focal length lens:

Aperture Diameter* (d) in Millimeters	Fraction	Fraction Reduced	f
80	80/80	1/1	1.0
56.6	56.6/80	1/1.4	1.4
40	40/80	1/2	2
28.3	28.3/80	1/2.8	2.8
20	20/80	1/4	4.0
14.1	14.1/80	1/5.66	5.6
10	10/80	1/8	8
7.1	7.1/80	1/11	11
5	5/80	1/16	16

*As area of aperture reduces by half, to allow half as much light to pass in a given time, aperture diameter reduces by $\sqrt{1/2}$.

24

At infinity focus, the diameter of the aperture at f8 is the same measurement as $\frac{1}{8}$ the distance from about the middle of a normal lens (actually the lens emergent nodal point) to the film.

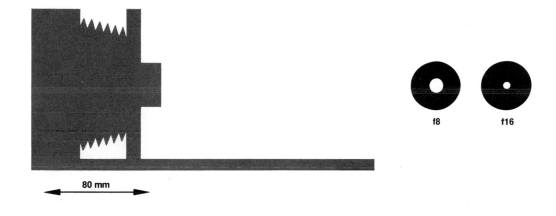

80 mm

The notations f8 and f16 denote fractions: aperture diameters $\frac{1}{8}$ and $\frac{1}{16}$ of the lens focal length.

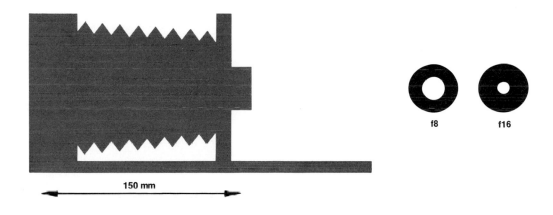

150 mm

Note that as the lens focal length increases, the actual size of the aperture increases also, but its fraction of the focal length remains constant.

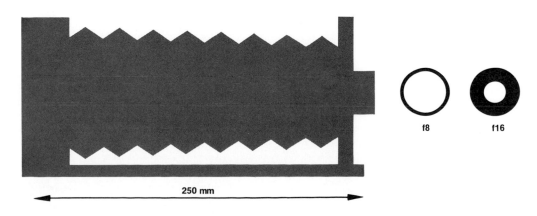

250 mm

About Film

The differences that concern us, between one film and another, are largely in the areas of sensitivity to light (film speed expressed in an ASA or EI number), contrast, and granularity.

© Eastman Kodak Company

Segments of enlargements made from a fine (top), a medium (middle) and a coarse grain film. Usually, the slower the film, the finer the grain.

To make a sweeping generalization: the lower the film speed, the greater will be the capacity for tone separation (contrast), the less the apparent graininess, and the greater the apparent sharpness of image. (If this sounds suspiciously like a plug for slow films, it is.)

One last thing: The film's sensitivity to light is a quality built into it at the time of manufacture. There is no magic developer formula or degree of push-processing, that allows you to consistently increase film speed without compromising your standards of print quality. After all, push-processing is simply photographic jargon for underexposure and over-development. When photographing normal and long luminance range scenes, underexposure (resulting from rating an ASA 400 film at EI 1200, for example) sacrifices shadow tone separation and detail. Over-development increases graininess, highlight film density, and contrast, and has little, if any, useful effect in the shadow areas. Sometimes, though, *short* scene luminance range and variations in emulsion manufacture team up with a bit of well-timed luck to help you produce a superb image though you over-rated the film speed, and over-developed for some arbitrary amount of time. Sometimes.

More often, film is pushed by photographers when scene luminance range is *long*. (Darkish room with a spotlight on the performer.) This technique results in a negligible gain in shadow detail in the negative (often lost in the printmaking), and overly dense highlights in the film, setting the stage for a difficult printmaking job.

On the other hand, there may occasionally be an advantage to rating a film at *less* than the designated ASA—overexposing the film by using an Exposure Index of 50 or 25 rather than its designated ASA 100. One such occasion is when luminance range is very long; at the beach on a sunny day, for example. The additional exposure provides the negative with more detail and tone separation in the shadows, and, with appropriately shortened development time, keeps the highlights in check. The result is an easier printing job, and an image with rich shadow detail.

To summarize all that's been covered:
1. Light meters measure object luminance and scene luminance range.
2. Light meter numbers, camera lens openings, and camera shutter speeds designate doubling intervals related to luminance.
3. Objects are not of a common luminance. Those you choose to photograph cannot be presumed to have an 18% reflectance; nor can it be presumed that no matter what their luminance, they would look best to you when placed precisely at the 18% reflectance level of the gray scale.
4. Scenes are not of a common luminance range, nor do they all have the same average luminance.
5. With constant developing time, density range of negatives is long when scene range is long, and short when scene range is short.
6. Generally, a given contrast grade of photographic paper is capable of matching *one* density range of negative.

Therefore:
You must apply a method by which you read the luminance of a chosen object and the range of the scene with your meter, and with appropriate consideration of your film's traits, and a pre-calculated degree of film exposure and development, control your film density so that
A. The chosen object is produced in your print to the desired density
B. Each scene range, as recorded on the negative, matches the response range of your choice of photographic paper.

There are occasions, of course, when you may have to compromise "A" to obtain "B", and vice versa. But this is a decision you make, in advance, before tripping the shutter. It is *your* editorial, subjective decision, and not your meter's.

Chapter 4
Expose Test Film

The test procedure for the Photographic Tone Control System consists of four interrelated photographic activities:

1. Exposure of four rolls of film
2. Film development
3. Assembly of four step tablets from exposed and developed films
4. Making photographic prints from these tablets; prints upon which all future exposure and development calculations will be based

It is essential that this test be run as carefully as possible, with accurate notes made at each step. The purpose of the test is to provide you with a personal data bank of exposure and development information keyed to your own meter—its accuracy and sensitivity; your film—its speed and contrast characteristics; your developer—its activity characteristics; and your personal film development technique—the unique effect of your developer agitation pattern on negative contrast and range.

The results of the test will vary from one kind of film to another. For this reason, you should test each film type that you expect to use with the system. If, for example, you plan to use both Plus-X and Tri-X films in practice, it would be necessary to run a discrete series of tests with each.

Play it safe: allow an uninterrupted
period of about two hours to set up,
make your calculations, work up your
Film Exposure Form, and expose the
four rolls of film.

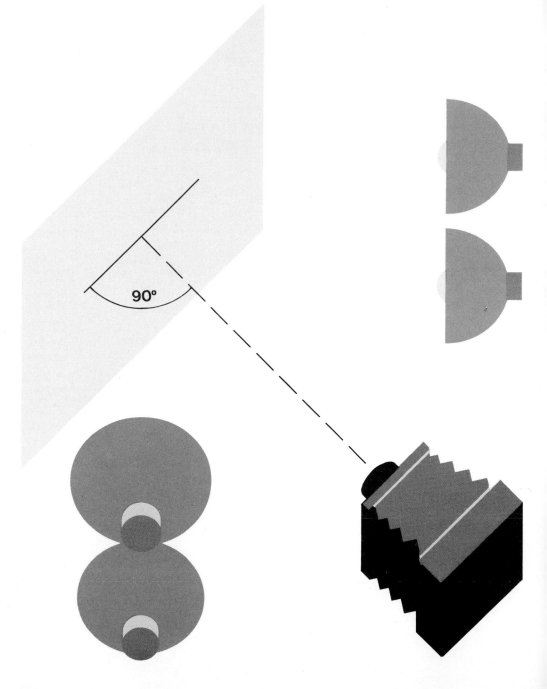

I. Prepare Test Area

A. *Tack up a blank sheet of paper* approximately 2 feet by 3 feet on a wall. The paper should be white and smooth, but not glossy. Although it is white, the meter will provide you with an exposure for it to appear on your test print as 18% gray. White paper is required to make it easier for you to obtain a meter reading of the target that is *at least five full lens stops down from wide open* with the shutter speed set at $\frac{1}{8}$ second or shorter. It should be remembered also that color in the target could prejudice the results because of the chromatic sensitivity of both the film and the light meter. In a later chapter we will deal with these chromatic characteristics.

B. *Evenly illuminate the target.* (This is easily said.) Illumination indoors could be four photofloods in reflectors aimed at the paper surface from about a 45° angle. Specific color temperature of the photofloods is not important when used with current panchromatic films, as long as all the bulbs have a common Kelvin designation. They should all be new and preburned for about fifteen minutes to level off their output and color temperature. New bulbs are recommended because they are less likely to burn out in the midst of your four-roll test exposure series. In addition, a mixture of new and old bulbs often results in a different amount of light output from each, and makes even illumination more difficult to achieve.

● The phenomenon of reciprocity failure is explained in Appendix I.

If an adequate level of even illumination is not available indoors, consider setting up the test outdoors on a cloudless day when light quality and intensity will not change much during the film exposure series.

C. *Adjust intensity of illumination if necessary.* Take a light meter reading. For purposes of the test, it is essential that you begin with a reading that shows exposure to be at least five steps down from wide open, with a shutter speed of $\frac{1}{8}$ second or less. If your illumination is inadequate to permit this, you will have to add to your source of light. Here are the reasons:

1. Shutter speed must be $\frac{1}{8}$ second or shorter to avoid any possibility of encountering reciprocity failure effects, should you have to reduce that speed once or twice later in the test.

2. A reflection intensity high enough to let you close down your lens at least five stops from wide open is suggested so that the lens may be opened in one stop increments to produce a very precise sequence of film exposures. By changing the lens aperture, you avoid having to move your lights or repeatedly change the speed setting on your camera. The lights are not to be moved at all during the tests; it is not practical. And, since speed settings on most cameras are not as accurate as lens stop settings, it is best to minimize shutter speed changes during the test, as well.

D. *Test the evenness of your illumination.* Move
● in close with your exposure meter and
read the white paper in the same pat-
tern that you are using to read this
page: across, and then down. The light
level over the entire target must be as
even as possible: within ⅙ of an expo-
sure meter number above or below
dead on. (Be prepared for a slight fall-
off in film density at the edges of each
frame, even with totally uniform target
illumination. This is due to complex
optical principles, not simply the cover-
ing power of the lens.) Be sure, when
taking the readings at this distance,
that your hand and meter do not cast
a shadow on your target. A spot meter,
which reads small areas from the cam-
era position, is particularly helpful
here, and of inestimable value through-
out all tone control photography.

E. *Set up your camera.*

1. *Position your camera* on a tripod, perpen-
dicular to the target, and so close that
the target image fills the film frame. If
you are working with a camera that
does not show, in the view finder, the
precise area being photographed, be-
cause the finder views the target from a
slightly different position than the tak-
ing lens—a twin lens reflex, for exam-
ple—be sure to compensate for it.

2. *Use a lens shade* to eliminate any
▲ possibility of lens flare caused by the
placement of your lights. Flare adds
non-image density to the negative,
which results in increased graininess
and lowering of shadow tone separa-
tion.

▲ Though flare light is usually the same
quantity throughout the tonal range, it
is a larger percentage of the total ex-
posure in the shadows than in the
highlights; therefore, it has a greater
effect on the shadows than on the
lighter steps of the tonal scale.

3. *Set the focus scale at infinity* so that the
surface texture of the target is not re-
corded. The film should record the
light reflection as a smooth, overall
tone. Infinity is suggested also because
some cameras are manufactured with a
built-in bellows. If you were to rack the
lens out, that is, extend the bellows,
you might very well be adding an un-
necessary additional exposure consider-
ation, that of the bellows-extension-
factor, to your calculations. Even on a
camera without a bellows, extending
the lens barrel to its closest focusing
distance reduces the light at the film
plane by about ⅓ of a stop, and intro-
duces unnecessary inaccuracy to the
test. Set the focus at infinity and avoid
problems.

II. Keep Accurate Records

Before continuing with the test proce-
dures, you will have to make some
notes on a Film Exposure Form copied
from the one you will find further
along in this chapter. Turn off the illu-
mination in your test area while you
do this; it will take time. Photocopy
the blank film exposure form and the
Sample Form as well. You will need the
latter for reference.

A. *Fill in Items 1 through 6.*

B. *Item 7* indicates all the one-full-stop-
apart lens openings on your camera,
and some more besides. Any numbers
not included (f/4.5, for example) are
not a full stop apart and should not be
used for the test. Circle *your* lens open-
ings on your film exposure form, as
shown on the sample form.

C. *Read the rest of this chapter* before completing Item 8 on your form. Refer to the sample form as you read. Item 8 consists of four columns: The frame numbers, the tone level reference code, the lens openings on your camera (along with some filter information), and your shutter speeds for the test.

1. *Frame Number:* This column is numbered 1 through 12. Note that frame #1 is not to be exposed. If your camera does not allow you to bypass frame #1, put a lens cap over the lens, or use some other method of *shutting out all light* before tripping the shutter. This first frame should be totally unexposed.

2. *Tone Level:* Designations in this column give you information that relates various luminances to each other. When you read a target with your light meter, then set your camera controls according to the meter's instructions, you get an exposure we call (E), related to a gray print value that matches the Kodak Neutral Test Card: 18% reflectance.

 Using (E) as a starting point (frame 6 on the sample form), we simulate additional luminance in consecutive one-number intervals (frames 7 through 12) and a reduction in luminance in one-number intervals (frames 5 through 2) to achieve the equivalent of a luminance range that encompasses eleven light levels. If you were to consider this set of eleven exposures as a single picture, the simulated scene range would be (-4) through (+6); the (-4) would be the darkest, and the (+6) would be the lightest parts of the scene.

3. *Lens openings:* In this column of your film exposure form, are recorded the lens openings that will be used to simulate the eleven luminance levels designated in column two.

 Next to the (E) tone level (frame 6), will appear the lens setting directed by your meter when you aim it at the target. In order to put one meter number *more* light on the film, you will open the lens one stop. It is designated (+1) (frame 7). Sequential full stop lens openings that appear on your lens will be shown alongside (+2), (+3), (+4), (+5) and (+6) (frames 8 through 12).

 In order to put one meter number *less* light than normal (E) on the film, you close your lens down one full stop. It is designated (-1) (frame 5). Sequential lens openings would be placed alongside (-2), (-3) and (-4) (frames 4, 3 and 2).

 As the sample form shows, for the (E) tone level (normal exposure), f/16 was used, five stops down from wide open (f/2.8 on the sample lens is wide open). The meter reading was such that at f/16 the speed was $\frac{1}{8}$ of a second. Next to the (E) (frame 6), f/16 was entered and the speed of $\frac{1}{8}$ alongside that.

 Above the (E) lens opening are entered succeedingly smaller lens openings that appear on the camera. *Below* the lens opening for (E), were entered succeedingly larger lens openings that appear on the lens. Notice that each lens setting is one of those listed in Item 7 (full stop intervals).

You may run out of different numbered lens openings before you complete the ⊝ to ⊕ range. Note that the sample lens ran out of different openings for ⊕, ⊖, ⊖ and ⊖. We will approach the ⊝ tone levels first.

The sample form indicates that the lens ran out of smaller apertures after f/22 (designated on the sample form as ⊝). At this point, rather than increased shutter speed, neutral density filters were used over the lens to arrive at the ⊖, ⊖ and ⊖ proper exposures.

- To arrive at ⊖, the ⊝ lens opening (f/22) was used, and in addition, a 0.3 N.D. filter was placed over the lens. To arrive at ⊖, a 0.6 N.D. filter was used. To arrive at ⊖, a 0.9 filter was used.

▲ It is suggested that you buy a three-inch 0.3, a 0.6, and a 0.9 gelatin square Kodak Wratten Neutral Density Filter No. 96 from your photo dealer. Using the 0.3 over the lens reduces the transmitted light to the film by one light meter number (or one lens stop); the 0.6 over the lens reduces the light to the film by two light meter numbers. To reduce the light by three light meter numbers, use either the 0.9 filter, *or place the 0.3 and the 0.6 together over the lens.* Various combinations of the three filters would give you additional light reductions should you need them *and all without changing the lens setting or shutter speed dial.* The alternative to using filters for the tone control test, is to double previous shutter speeds in sequence as noted in the sample form.

Filters are recommended because they are more accurate.

4. *Shutter Speeds:* In this column, enter your meter recommendation for ⓔ, just as you entered the recommended lens opening for it in column 3. Since most of the exposure changes for the test will be controlled by lens aperture changes and filters, most of the entries in this column will be the same. Notice that in the sample test form, it was possible to use the same shutter speed for all the exposures except one.

When the ⊕ exposure was reached, the lens had run out of large openings. Here, to create ⊕ (that is, to double the quantity of light used for the ⊕ exposure), the shutter speed was changed to twice as long as the ⊕ exposure. Use of the speed dial was thus held to a minimum, and is within the reciprocity limit of the film (normally, one second of exposure).

Now the sample form is complete. Frame 1 would be unexposed. The notations numbered frame 2 through 12 are the settings that would be used to expose those frames on each roll of film.

At this point, you should complete Item 8 in your form with your own data.

● Each 0.3 of neutral density provided by a filter placed over your lens reduces the light transmission by half, and is equivalent to stopping down the lens one full stop.

▲ Probably no more than the 0.3, 0.6 and 0.9 neutral density filters would be required for this test. If you plan to use films with a wide variety of exposure indices and want to expose them at a common lens opening and shutter speed, purchase these five filters instead: one 0.1 N.D., one 0.2 N.D., one 0.4 N.D., and two 0.8 N.D. Combinations of these filters provide an uninterrupted span from 0.1 through 2.3 making them useful both for these tests and for future work.

Although it is preferable to use the minimum number of filters to arrive at the total required density, this economy measure is worth considering. Instructions regarding the use of neutral density filters in making different film speeds compatible appear in Appendix III.

Photographic Tone Control

Film Exposure Form

1. Date 24 APRIL 77

2. Light Meter PENTAX 1°/21° SPOT

3. Camera H'BLAD

4. Lens 80MM

5. Film PLUS-X PROF

6. Exposure Index (ASA) 125 Ⓔ

7. Lens Opening 0.7 1.0 1.4 2.0 (2.8 4.0 5.6 8 11 16 22) 32 45

*ALTERNATE SETTINGS
WITHOUT
N.D. FILTERS
④ f 22 @ ¹/60
③ f 22 @ ¹/30
② f 22 @ ¹/15

8. Frame Number	Tone Level	Lens (+N.D. Filter)	Shutter Speed
1	(F*)	Unexposed	Unexposed
2	(−4)	f/22 +0.9 ND	1/8*
3	(−3)	f/22 +0.6 ND	1/8*
4	(−2)	f/22 +0.3 ND	1/8*
5	(−1)	f/22	1/8
6	(E)	f/16	1/8
7	(+1)	f/11	1/8
8	(+2)	f/8	1/8
9	(+3)	f/5.6	1/8
10	(+4)	f/4	1/8
11	(+5)	f/2.8	1/8
12	(+6)	f/2.8	1/4

*Film Base Plus Fog

Exposure of sheet, rather than roll film is described in a special section of this chapter beginning on page 39. It is recommended that you read all the material in this chapter before considering this alternative.

III. Expose your film

A. The exposures should be made in the frame sequence indicated on your film exposure form, so that each frame will be keyed to precisely documented data. Reload your camera and repeat the procedure three times to produce four rolls of identically exposed film.

B. If you use 35mm film, your test exposures should be made on the length of roll you normally use, because the developer exhaustion rate and the effects of agitation are not the same for a 20 exposure roll as for a 36 exposure roll. Unless you have more than one 35mm camera body, it is suggested that you standardize on the smaller film cartridge, since the use of the Tone Control System will require you to expose an entire roll to the same luminance range. These are your special instructions:

1. Use the first twelve frames as instructed in this chapter.

2. Expose all but two of the remaining frames at the same lens opening and speed you used for \textcircled{E}. This will provide for an approximately normal developer exhaustion rate when the roll is processed.

3. Overexpose frames 18 and 19 on a twenty exposure roll, or frames 34 and 35 on a thirty-six exposure roll, at least ten times the exposure time (in seconds) used for $\textcircled{+6}$. This provides you with a very dense area which you will later be instructed to use for your step tablet template. Those instructions will appear in a special section in Chapter 6.

Expose your four rolls of film identically. Good luck.

Photographic Tone Control

Film Exposure Form

1. Date	

2 Light Meter

3. Camera	**4. Lens**
5. Film	**6. Exposure Index (ASA)**

7. Lens Opening	0.7	1.0	1.4	2.0	2.8	4.0	5.6	8	11	16	22	32	45

8. Frame Number	**Tone Level**	**Lens (+N.D. Filter)**	**Shutter Speed**
1	(F*)	Unexposed	Unexposed
2	(−4)	f/	1/
3	(−3)	f/	1/
4	(−2)	f/	1/
5	(−1)	f/	1/
6	**(E)**	**f/**	**1/**
7	(+1)	f/	1/
8	(+2)	f/	1/
9	(+3)	f/	1/
10	(+4)	f/	1/
11	(+5)	f/	1/
12	(+6)	f/	1/

*Film Base Plus Fog

Special Section:
Sheet Film Exposure

If, instead of testing with roll film, sheet film is used, it is suggested that each unit in the twelve frame sequence be on a separate sheet of film. The twelve sheets, developed together, would provide the same type of information as that described earlier for the roll film. This means, then, that a total of 48 sheets of film are required, developed in batches of a dozen, and each sheet identified by some sort of convenient punching, or corner-clipping system for exposure identification.

At this point you may be tempted to short-cut this procedure—to compute exposures that would allow you to insert the dark-slide part way into a film holder, and by multiple exposure, obtain more than one tone level on a given sheet of film. Two side-by-side exposures would cut the film requirement in half. Three on a sheet would provide even greater savings and ease of film development. The logic is excellent, but the procedure is not recommended.

This approach is not endorsed because of the fact that multiple exposures on film do not necessarily equal the sum of their separate exposure times. (Four $\frac{1}{8}$ second exposures may not create the same effect as one $\frac{1}{2}$ second exposure.) This condition, called an "Intermittency Effect", is in fact, a type of reciprocity failure. Although research in this area was begun more than eighty years ago and continues today, the application of available formulae is too complicated for practical use. Among the variables involved in its computation are: film grain size, intensity of exposure, length of exposure, number of exposures, and time interval between exposures.

Again, if you want reliable results, use twelve sheets of film for each of your four planned development times. You will avoid the possible misinformation that might be generated by an Intermittency Effect.

Chapter 5
Develop Test Film

For sheet film development, follow all instructions in this chapter, except those pertaining to roll-film development tanks.

Your four rolls of film are now ready to be developed. Successful results will depend upon your strict adherence to the instructions in this chapter.

I. Prepare your equipment

A. *Development Tanks* for roll film come in two basic types:

1. *Center Spindle Type:* To agitate the film and developer with this type of unit, a spindle is inserted through a hole in the center of the tank lid and engages the reel holding the film. The spindle is then used to rotate the reel. The developer agitation pattern, though scroll-like, is essentially linear. Since any development procedure causes the developer in contact with the film emulsion to become locally exhausted depending upon the degree of activity in a particular area of the film, the spindle type of tank, with its linear agitation pattern, often invites streaking (called "bromide drag") caused by such locally exhausted developer. *This type of tank should not be used.*

2. *Inversion Type:* In order to agitate the developer using this tank, you invert and twist it, setting up a developer agitation pattern that, properly done, is nearly random.

Such agitation is more likely to produce consistently streak-free, evenly developed negatives. Each person's unique agitation technique also affects the film's density range and image contrast. That is one reason why the Photographic Tone Control System—which is built on *your* developing methods—is more accurate for you than simply adopting someone else's results.

Streaks, resulting from improper film developing technique, are most apparent in areas of flat tone.

b. Pre-fill the tank with developer, rather than pour in the solution after the reels are inserted. This is a preferred practice at all times, for even development and accurate control of development time.

c. If you are using a tank that holds more than four reels, be sure to fill the rest of the tank with blanks at the very start. Replace each reel you withdraw from the tank with a blank one, so that there are always the same number of reels in the tank.

Should you neglect to replace each withdrawn reel with a blank, the piston-like movement of the remaining reels will subject the film to an incalculable amount of increased agitation, and may very well invite film streaking. The resulting films would not be an accurate guide for gathering photographic tone control data.

In the development instructions that follow you will be directed to develop each of the four test rolls of film for a different length of time. This can be done with a single reel tank, and a separate processing cycle for each roll.

An alternate method is to use a multiple reel tank, and at pre-determined intervals, remove one reel at a time from the developer and transfer it to the stop and fix. If you opt for this method, with all four reels in one tank, you must:

a. Code each roll before you put it on the reel, preferably with holes punched in the leader or trailing end, so that the development times will be identifiable on the film. For example, first roll in (last one out, longest development time) punch 4 holes; next roll 3 holes, and so on.

d. Set aside separate containers filled with stop bath and fixing solution for use as each roll reaches completion of its development time. It would be easier at this point, if you had an assistant to whom you could hand each reel as you remove it from the developer, and who could continue with the stop, fix and wash, while you replace the removed reel with a blank, and continue the development cycle with the balance of the reels.

B. *Film Developers* must be chosen and handled carefully:

1. Use a One-Time Developer: A one-time formula is a developer that is discarded after a single use. It is recommended because it provides a greater potential for consistent results. All developers are affected to some degree by oxidation, and with use, by exhaustion and contamination.

Subsequent rolls of film in a re-used developer are not acted upon with the precise degree of developer effectiveness as earlier rolls. In addition, developer-replenishment systems designed to maintain constant developer strength, are at best, only approximate.

There are many good one-time developers on the market, and in the interest of consistency—repeatable results—it is recommended that you use one of them.

2. Use a developer that has a manufacturer's recommended development time for your film of *eight minutes* or more. The reason for requiring 8 minutes minimum for normal development is that one of the four rolls you will be processing will have a developing time of 50% less than the normal.

With a normal time of 8 minutes, 50% less would be 4 minutes, a safe length of time with some margin to spare. Less than 4 minutes of development time substantially increases your risk of coming up with unevenly developed, mottled film.

3. Maintain accurate temperature control: Developer activity increases with its temperature and as a result, affects film density range and contrast. Since the only variable in this test should be development time, it is imperative that developer temperature be constant for all four rolls of test film, and for future film development based on this system.

D – 50%	D – 25%	D* (NORMAL)	D + 25%
4	6	8	10
4½	6¾	9	11½
5	7½	10	12½
5½	8¼	11	13¾
6	9	12	15

*Developer Manufacturer's Recommendation in Minutes.

Remember:
— Inversion style tank
— One-time developer
— Developer with normal development time of at least 8 minutes
— Standardized developer temperature

II. Work up the Film Development Form

Copy the form provided on page 49. Completed, it will serve as both a permanent record and a specific darkroom guide for developing your test rolls. Refer to the Sample Form as an example.

Most of the items on the form will be answered according to the specifics of your own choice of materials and methods. Your attention is drawn, however, to Item 5: Time. Fill in this part of the form according to the following time schedule:

One roll: Normal time (recommended by manufacturer): D
One roll: 25% more than normal time: D+25%
One roll: 25% less than normal time: D−25%
One roll: 50% less than normal time: D−50%

The Sample Form shows that if you were using a developer with a manufacturer's recommended time (D) of 8 minutes, you would enter 8 minutes on your Film Development Form under Item 5 on the appropriate line. Above it would be 25% less time—6 minutes. Above that, is D-minus-50%, or 4 minutes. Below D, you would enter 25% more than normal time, 10 minutes. On the finished form, the sequence would read 4 minutes, 6 minutes, 8 minutes and 10 minutes.

If you were to use a four-reel tank and follow this sample timing, you would remove the first reel and replace it with a blank after four minutes. Two minutes later, the 6-minute reel would be removed and replaced with a blank. Then, after two more minutes, the 8-minute reel would be removed and replaced with an empty reel. And two minutes later, the last loaded reel would be removed. Note that this method and this size tank require that you have available seven reels at the start.

In the case of fractions of a minute, it may be practical to adjust your time calculations to the nearest $\frac{1}{4}$ minute for this test. Simply keep a record of the time you choose.

Develop your four rolls, following your notes precisely, and using your normal agitation technique, normal stop bath, normal fix, wash, etc.

Photographic Tone Control

Film Development Form

Date 24 APRIL 77

1. Developer EDWAL FG-7

2. Dilution 1:15 WITH WATER Temperature 70°

3. Agitation Rate CONTINUOUS FOR FIRST 30 SECONDS, THEN 5 SECONDS OF EACH 30

4. Tank NIKKOR MULTI-REEL (4/120)

5. 50% Less Than Normal Time (D – 50%) 4 MINUTES

 25% Less Than Normal Time (D – 25%) 6 MINUTES

 Normal Development Time (D) 8 MINUTES

 25% More Than Normal Time (D + 25%) 10 MINUTES

6. Stop Bath (Brand and Dilution) SB-1 Time 30 SEC

7. Fixer (Brand and Dilution) NH-5 (1:3) Time 3 MIN

8. Wash Time 30 SEC

9. Hypo Eliminator (Brand and Dilution) EDWAL 1:15 Time 1 ½ MIN

10. Wash Time 5 MIN

11. Wetting Agent (Brand and Dilution) PHOTO-FLO CAP TO 40 OZ. Time 30 SEC

III. Evaluate your results

This should be done when the developed film is dry. There are a few facts that can be learned from a quick visual check of the negatives:

A. Confirmation of evenness of target illumination:
If within each frame there is a nearly constant density, your target was evenly lit. Some small density variation along the edges of the frame is almost always present. However, if there is obvious tone difference across a frame, such as a hot-spot of increased density, it would be disheartening but necessary for you to begin again, being especially careful this time to light the target evenly. (This assumes the covering power of the camera lens is adequate for the film size.)

B. Confirmation of proper agitation technique:
If the film tone value in each frame is not smooth (and you remembered to set your lens at "infinity" for the exposure test) it would be wise to re-evaluate your method of agitation. Very minor variations in tone are to be expected, but easy-to-see streaks or mottle is a signal that it would be better to begin again.

C. Visual evaluation of density range:
While Frame #3 (-3) looks substantially the same on all four rolls, note that Frame #9 (+3) is far denser on the 25%-over-normal-development roll, than the corresponding frame on the roll that received only 50% of the normal developing time. This confirms the fact that *film development time has a direct and precise effect on film density range.* Notice also that even Frame #6 (E) increases in density with development time. The greatest increase in density with longer development will be seen in the frames that had the greatest exposures. The weakly-exposed frames will show only a slight change in density.

When this phase of your tone control test is complete, you are ready to assemble four step tablets from these films.

The developer agitation technique shown here provides evenly developed, streak-free negatives.

1. Start with the tank held upright in your left hand.

2. Grasp the top of the tank with your right hand. This creates a 90° angle between the forearms.

3. Bring hands closer to the body. This increases the angle between the forearms to about 180° and slightly rotates the tank.

4. Transfer the weight of the tank to the right hand . . .

5. . . . as you fully invert it.

6. Then grasp the tank with the left hand, again making a 180° angle between the forearms.

7. Transfer the weight of the tank to the left hand. The tank will again naturally rotate . . .

8. . . . as you invert it.

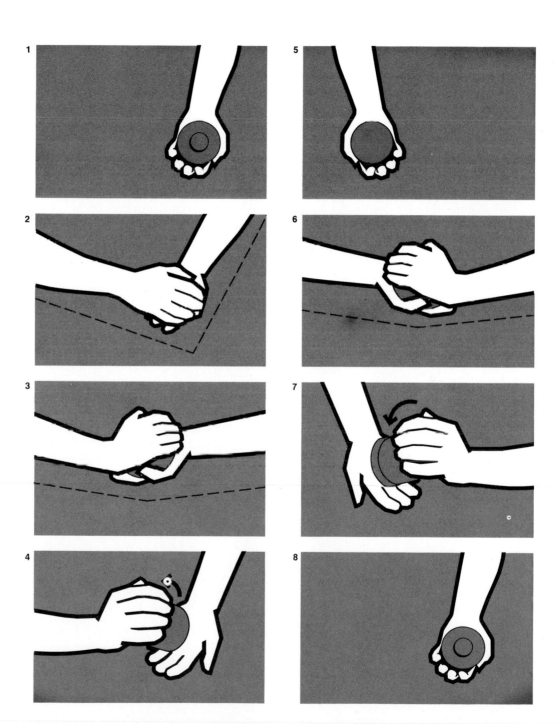

Photographic Tone Control

Film Development Form

Date

1. Developer

2. Dilution Temperature

3. Agitation Rate

4. Tank

5. 50% Less Than Normal Time (D − 50%)

 25% Less Than Normal Time (D − 25%)

 Normal Development Time (D)

 25% More Than Normal Time (D + 25%)

6. Stop Bath (Brand and Dilution) Time

7. Fixer (Brand and Dilution) Time

8. Wash Time

9. Hypo Eliminator (Brand and Dilution) Time

10. Wash Time

11. Wetting Agent (Brand and Dilution) Time

Chapter 6
Assemble Step
Tablets

For 35mm film, a slightly different procedure is necessary. See the special section starting on page 54.

Each roll of your test film will now be used to assemble its own step tablet—the negative tonal scale that resulted from exposing your film to a simulated eleven-number meter range, and then developing for a pre-calculated length of time. Prints made from these step tablets will make it possible for you to see the specific light-meter-scene-range reproducible with each development time, and will become an invaluable reference source.

Preliminary inspection of the four rolls of film has already shown that the negative density range of each roll is different from the others. The purpose of the step tablets is to show you how these differences relate to printmaking.

We will get to the printmaking phase of the tone control test after assembling the four step tablets and creating an "18% spotter," a simple device for isolating a precise medium gray print tone.

I. Assemble Four Step Tablets

A. *Prepare your templates:*

1. A piece of opaque material slightly larger than a single frame of the film you used for the test is required for each template. Since this will be inserted into your enlarger, be sure it is of sufficient size to span the opening in a glassless negative carrier, if that is what you customarily use.

An excellent material for this purpose is high contrast litho film exposed and fully developed in lith-type developer so that it is jet black. This film is usually manufactured in .004 and .007 thickness, and although the .007 is somewhat more rigid and durable, either will serve your purpose well.

If litho film and developer are unavailable, a vastly overexposed and overdeveloped sheet of conventional film would be adequate. Simply expose the sheet of film to daylight—without a camera—and develop it for at least normal development time. It is not necessary to develop the film in the dark. Stop, fix, wash and dry it normally. It will then be ready to use.

2. Within the "live" area of the template—an area that represents the image carrying portion of a negative—punch a total of twelve holes with a conventional quarter-inch hole punch.

If your test was run with sheet film, make the templates from vastly over-exposed and overdeveloped sheets of the same size film you used for the test. Cut out the center section as shown below, punch twelve holes, and tape the section back into the sheet.

B. *Complete the first step tablet:*

1. In sequence, cut out a half-inch square, or punch a half-inch disc from each of the twelve frames of one roll of your developed film. Cut each section from about the center of the frame for greatest consistency. As noted previously, there is always some density fall-off at frame edges. Place these film chips over the template holes in the order illustrated on the facing page.

 Notice that the sequence is such that, although the twelve test pieces are set in four rows, sequential exposures are adjacent on the template.

2. Cut narrow strips of Scotch tape and tape down the film chips, being careful to keep the tape from extending into a live area of the chip (i.e., where it is over a template hole).

3. When the Ⓔ patch is in place, put needle holes above, below, to the left and to the right of it on the template, as indicated by the four dots in the illustration. This is an important procedure; it will serve as a quick reference in printmaking by showing you at a glance which patch must be exposed and developed to an 18% gray value on your print.

4. Mark on the template, the time the roll spent in developer (D, D−50%, D−25% or D+25%).

C. Assemble the three remaining step tablets in the same way being careful to:
— Maintain proper sequence
— Mark the Ⓔ patch
— Indicate the film developing time of that particular template of chips.

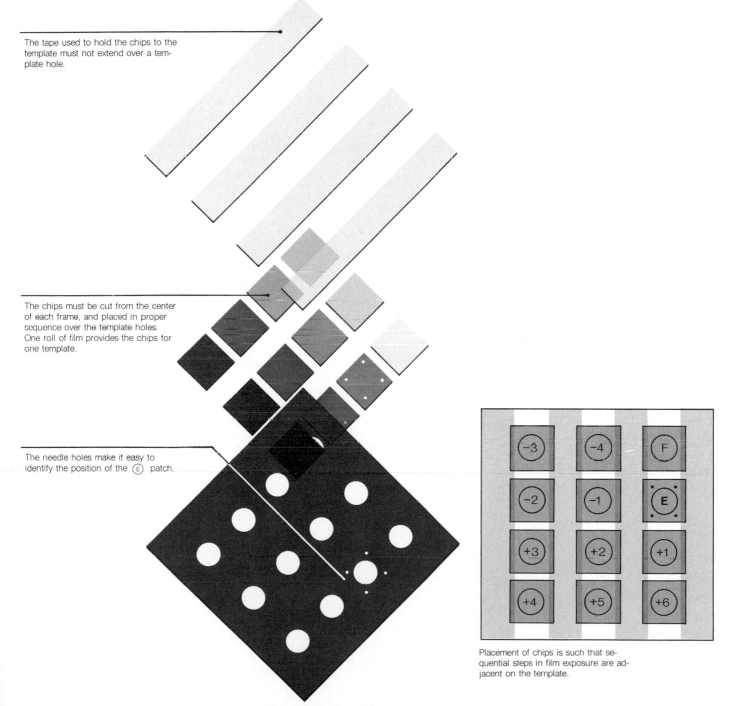

The tape used to hold the chips to the template must not extend over a template hole.

The chips must be cut from the center of each frame, and placed in proper sequence over the template holes. One roll of film provides the chips for one template.

The needle holes make it easy to identify the position of the (E) patch.

−3	−4	F
−2	−1	E
+3	+2	+1
+4	+5	+6

Placement of chips is such that sequential steps in film exposure are adjacent on the template.

Special Instructions for those who are using 35mm film

Punching twelve one-quarter inch holes within a template area representing a single 35mm frame, then assembling and attaching film chips over them, is not impossible, but it is difficult and therefore impractical. This alternate procedure is recommended:

1. Read the instructions above that relate to a larger film format; they contain important ideas.

2. Clip off the last four frames from one of the four 20-exposure or 36-exposure rolls you have just developed. The two center frames are quite dense, and will serve as your template—the area within which the film chips will be placed. The two outer frames make the template easier to handle in the enlarger, and give you space on which to affix a paper label marked with development time.

3. Punch six holes in each of the two dense center frames, allowing room for taping down the chips.

4. Cut or punch a half-inch chip from the center of each of your first twelve frames, and position them in the sequence shown. Tape them to the template. Next, place needle holes, on the four sides of the Ⓔ chip.

5. Attach a label to one of the outer frames, and mark on it the time the roll spent in the developer.

6. Assemble the three remaining step tablets in the same manner.

Special instructions for exposing this tablet (during the printmaking part of the test) are provided at the end of the next chapter. Be sure to read the complete chapter before referring to your special instructions.

This is the sequence of chip placement. One frame holds chips Ⓕ through Ⓔ , and one frame holds chips ⊕ⓣ through ⊕ⓖ

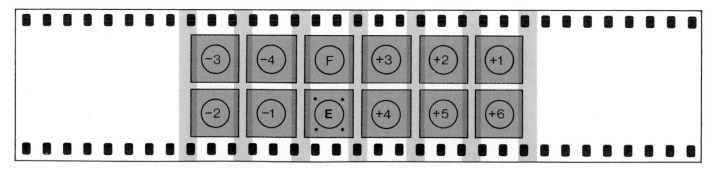

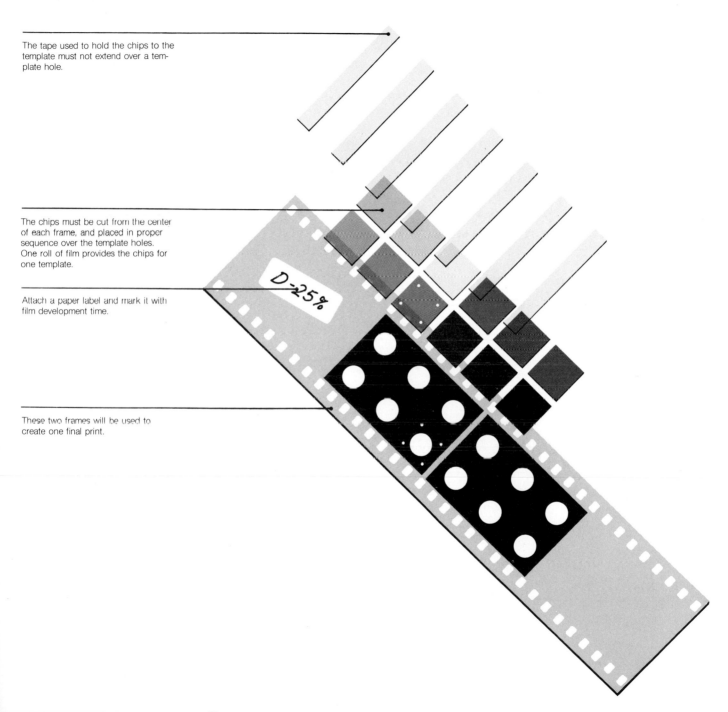

The tape used to hold the chips to the template must not extend over a template hole.

The chips must be cut from the center of each frame, and placed in proper sequence over the template holes. One roll of film provides the chips for one template.

Attach a paper label and mark it with film development time.

These two frames will be used to create one final print.

D-25%

II. Create an 18% Spotter

A spotter is a comparison patch to be used in the printmaking. Earlier, it was suggested that you buy Kodak Neutral Test cards. Each card is quite thick. If you are careful you will be able to peel the 18% gray surface away from its mounting board. Cut off a patch about 2″ x 2″ and separate it from the backing. Then punch a $\frac{1}{4}$″ hole in the center of the 2″ x 2″ square.

The patch, with a hole punched in it, serves as an excellent reference. When you examine your finished print in the fix or wash, you will place this patch over the \textcircled{E} image area, and compare the spotter to the \textcircled{E} gray value that shows through the hole. The \textcircled{E} in a dry print must be as close as possible to this reference.

Now that the four step tablets and the spotter are complete, you are ready to make the four prints.

Chapter 7
Make Test Prints

You will now make a photographic print with each of the four step tablets.

I. Select Your Equipment and Materials

A. Large prints (16 x 20 and greater) show slightly lower contrast than smaller ones due to the degree of their enlargement. If your prints are primarily in an extreme size, the tests should be made in that magnification for accurate data. Otherwise, 11 x 14 is a good size for your test prints.

B. Use the enlarger lens you normally use for your size of negative.

C. Use the print developer on which you choose to standardize; the development time and temperature should be in accordance with the manufacturer's instructions.

D. The photographic paper should be a brand and grade you normally favor and will want to use when you start to put the system into practice. Although many types and brands of photographic paper have the same contrast grade number, do not assume they will reproduce the same number of steps on your print from a given tablet. Each paper must be tested separately. What may be a range of $+2$ to -2 on one kind of paper may easily be $+2$ to -3 on another.

E. Check for uniformity of light on the printing easel. Since this can vary by as much as a full stop from center to corners, be sure to center your photographic paper under the lens.

II. Make Your Prints

Begin with the template marked D+25%.

Since from the very start, all the calculations have been based on the 18% print reflectance of gray derived from light meter readings, it is logical to key your test prints to this specific tone.

Therefore, the film negative patch on the template corresponding to Ⓔ (indicating light meter recommended exposure) should be timed to produce 18% gray on the print with normal development. ⊕ exposures will, at the same time, reproduce as lighter gray values, and ⊖ exposures will reproduce as sequentially darker values.

Only enlarger exposure time and lens opening should be adjusted to arrive at 18% gray in the Ⓔ patch; *development time should not be changed.*

It is a good idea to use small test strips first, to establish the Ⓔ print exposure before printing an 11 x 14 of the total step tablet.

After the print (or test strip) has been in the fix or wash water, lift it out and place your spotter over the Ⓔ patch and compare your results to it. Keep in mind that your print, as virtually all photographic prints, will dry somewhat darker. If you think you have a perfect match to the spotter, make another print or two slightly lighter so that when they are dry and compared to the spotter, one of the three is an accurate match to the 18% reference.

Record your data: Be certain the film development time indicated on the template is marked on the back of the print, to avoid confusion later.

There is a Tone Control Printmaking Form at the end of this chapter, along with a Sample Form. Fill in the blank form with your own data.

Note: If you use an easel meter: Once the exposure time for a correct Ⓔ has been established, put the probe on each of the tablet images that is represented with a tone on your print, and make a note of the meter reading of each. Later on, should you want to duplicate one of those tones—say, just off pure white—your meter reference should save you considerable time.

Make prints of the remaining three step tablets. Since the Ⓔ patch changes in film density with film development time, each print will require a different enlarger exposure. An easel probe reading of Ⓔ on the first print would be of assistance here, but the more conventional test strips will serve very well if you do not have an enlarger meter.

III. Interpret and Adjust Your Results

A. The range you see is affected by two things:

1. A wet print looks different, particularly in the shadows, from a dry print. There is far more shadow tone separation in a wet print. Make your range judgments and comparison to the base+fog patch only on dry prints.

2. Illumination level when viewing your test prints will affect shadow tone separation. View your prints in a light level of 200 footcandles. (A household 100W frosted incandescent bulb in a 10″ diameter metal photobulb reflector placed at a distance of 30 inches from the viewing surface provides about 200 footcandles of illumination.)

B. You will find that with each of the four step tablets you reproduced a different "scene" luminance range without changing the contrast grade of photographic paper. Observe also, that the shorter the developing time the negative received, the longer the usable luminance range it shows. The usable luminance set can be interpreted in terms of the number of tones above \overline{E} until no image appeared, plus \overline{E}, plus the number of tones below E before the differences in very dark patches were not apparent. The darkest $-$ tone to include in your luminance set should be a bit lighter than the base+fog patch, F, made with the unexposed film negative. Mark the specific $+$ or $-$ value over each useful patch in sequence on each print. Then mark the luminance set on each print. (For example -3 to $+2$ is a 6-tone luminance set).

C. If in each case, with E on the print matching the spotter, the print had rich shadow values in the minus areas (-2 or -3 or -4), everything would be fine. But you are likely to find that on the print made with the 50%-less-than-normal development step tablet, although the E—18% value—is a match to the spotter, even the deepest shadow—-4—is weak.

The reason for this is that normal film development time increases density in the film middletone E and highlights, $+$ patches, at a far faster rate than in the shadows, the $-$ patches. But shortened development time (D−50%) does not provide adequate opportunity for a normal effect.

As a result, on this D−50% roll, the $-$ film frames are not very much different in density from the E frame. Consequently, the print tones created by the $-$ patches are not sufficiently different from the print tone of the E patch. The $-$ patches in the print are darker than the E, but even the darkest patch (base+fog) is not really black on the print.

·The flattening effect of this shortened film development time works to your advantage in that a greater overall span of luminance is recorded on your print; and for the moment, the disadvantage is that the print shadows are not really black. Overcoming this momentary disadvantage is simple. Here is how it is done:

1. Note which patch on your D−50% tablet is the $+1$ patch.

2. Make a new print in which this $+1$ patch—rather than the E patch—is recorded on the print paper to match your spotter.

3. Notice that now, when the $+1$ patch is used to create the 18% reflectance value, the shadows are darker, and at least one of the $-$ patches is a rich dense black. Notice also that the balance of the patches create a long scale of tones.

4. On this newly made print, mark the film designation. Instead of the ASA listed on your Film Exposure Form, write "Exposure Index", and put down a number that is one half the ASA shown on the form.

5. Now mark the individual patches on this new print in the following manner:

a. The patch which you used to create the 18% gray reflectance should now be marked (E).

b. Sequentially lighter patches should be marked (+1), (+2), etc.

c. Sequentially darker patches should be marked (−1), (−2), (−3), etc.

6. Discard the earlier print that did not yield a dense black shadow patch.

When photographing a scene with as long a luminance span as the one shown on this print, you must first re-set your exposure meter to this lesser Exposure Index. By exposing the (+1) patch on your step tablet to create an 18% gray on the print, you actually exposed the film as though it had this "slower speed"— one lens stop slower. And since ASA film speeds are also computed in halving intervals, using the (+1) patch actually was the same as cutting the film speed in half. (To go one step further, if it were necessary to use the (+2) patch to create the 18% gray print value in order to arrive at adequately dense shadow patches, your exposure index would be one quarter of the original ASA.)

Remember: The degree of sensitivity of film to light is a quality built into it at the time of manufacture. You are not really changing that degree of sensitivity by using a reduced exposure index. You are re-setting your meter because it is the easiest way to allow a calculated amount of additional light to be gathered on the film. The film will then respond to this additional light by producing greater differences in density between the shadow and midtone steps, even with very short development time.

When you have completed this set of four special photographic prints, you will know the scene range that your print paper can reproduce in terms of exposure meter numbers for each film development time.

Now, by simply selecting what you consider the significant scene highlight and shadow luminance and comparing the meter number span to the number of steps on each of the four test prints, you will know exactly what exposure and film development time will result in the best negative for the print you have in mind. For the first time, your film exposure and development are accurately keyed to:

— Scene luminance range
— Your exposure meter and camera
— Your film speed and contrast characteristics
— Your enlarger; its design, lens, and light source
— Your photographic paper and contrast grade
— Your photographic paper developer
— Your interpretation of the scene

Your test prints are valuable. Wash them thoroughly, mount them, and use them often for reference. Be sure to complete your Printmaking Form. It will help you to draw vital conclusions from the data you have collected. Further analysis of your test prints follows in the next chapter.

Special Printmaking Instructions For 35mm Step Tablet

The purpose here is to create, on a single sheet of print paper, the same sequence of images described earlier in this chapter. The method is substantially the same, with one exception: you will expose Frame A, the one with the Ⓔ chip on it, and then move the photographic paper down and expose Frame B, in order to create one finished print. Here is how:

1. Place Frame A in the negative carrier aperture and project its image onto the lower half of the print paper area. Center this half of the paper under the lens. Be sure the projected image is positioned in such a way that the next exposure (from Frame B) will fit above it to give you one, uninterrupted sequence.

2. Using the technique described earlier for the single-frame template, and the Ⓔ chip, create a print tone that matches the spotter.

3. Expose Frame A of the template to the print paper.

4. Slide Frame B into the negative carrier aperture, and move your print paper so that the Frame B image will be projected onto the upper half of your paper. *Use exactly the same exposure time and lens opening you used when exposing Frame A.*

5. Develop the print.

You have, in effect, created the same sequence of tones as you would have created in a single exposure, had the area on the template been large enough to accommodate all twelve chips. The advantage of this procedure, as opposed to arbitrarily making a template with a larger area, is that by keeping your chips within the 35mm format, you are able to use your normal focal length enlarging lens, normal carrier, and normal enlarger condenser placement. For this reason, the information provided by your test is valid, and a reliable reference.

A Word of Caution:
It is obvious that the accuracy, or at least the consistency, of your enlarging timer is essential to your success. The separate exposures of Frames A and B of the template must be identical in order to simulate a single exposure to all twelve chips. The most popular darkroom timers are often too inaccurate to be used for exposure-times of less than ten seconds. Therefore, unless you are certain that your timer is accurate, it is suggested that you key your enlarger lens opening to a 15 to 20 second exposure time. In that way, a slight inaccuracy becomes a smaller, and probably insignificant, part of the total exposure.

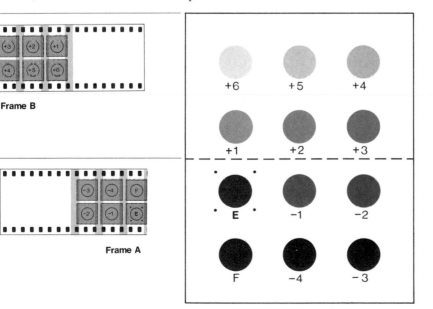

Frame B

Frame A

Photographic Tone Control

Printmaking Form

Date 25 APRIL 77

Enlarger BESELER 45 MCRX Lens 80MM

Degree of Enlargement* 5½×

Paper POLYCONTRAST RAPID F

Developer and Temp. & Time DEKTOL 1:2 70° 1½ MIN.

Stop Bath SB-1 Fixer NH-5

Roll	f/	Time	Print Response Set
D + 25%	16	14 Sec.	−2 TO +2 = 5
D	22	17 Sec.	−3 TO +2 = 6
D − 25%	22	16 Sec.	−3 TO +3 = 7
D − 50%*	22	15 Sec.	−4 TO +3 = 8

Easel Meter Readings	(−4)	(−3)	(−2)	(−1)	(E)	(+1)	(+2)	(+3)	(+4)	(+5)	(+6)
D + 25%			E12	E18	F15	G13	H12				
D		E10	F8	F13	F15	G11	H15				
D − 25%		E12	E16	F11	F16	G11	H8	H12			
D − 50%*	E10	E12	E15	F10	F17	G11	G16	H15			

* D-50% PRINT BASED ON EI 60 INSTEAD OF ASA 125

*The hole in the template is ¼". Measure the image diameter on print to calculate degree of enlargement.

Photographic Tone Control

Printmaking Form

Date

Enlarger Lens

Degree of Enlargement*

Paper

Developer and Temp. & Time

Stop Bath Fixer

Roll	f/	Time	Print Response Set
D + 25%		Sec.	=
D		Sec.	=
D − 25%		Sec.	=
D − 50%		Sec.	=

Easel Meter Readings	−4	−3	−2	−1	E	+1	+2	+3	+4	+5	+6
D + 25%											
D											
D − 25%											
D − 50%											

*The hole in the template is $\frac{1}{4}$″. Measure the image diameter on print to calculate degree of enlargement.

Chapter 8
Analyze and Apply Results

You can learn a great deal from your test results. This chapter pinpoints the important concepts evident in your prints and shows the applicability of these concepts in various photographic situations. Traditional darkroom techniques for enhancing photographic prints are also considered, and suggestions made in regard to expanding your basic data bank with further tests. In addition, various types of cameras are discussed in relation to the Photographic Tone Control System.

A comparison of your four test prints will show you, in the most meaningful way, the effect on negative range of a change in film development time. Immediately apparent also is the far greater range that negatives achieve, in comparison to photographic print papers. The entire eleven number luminance set which you simulated during film exposure registered on the film as density differences. But none of the photographic prints was capable of reproducing that eleven-number set totally. (It represents a luminance ratio of about 1000:1)

Most important, though, is the convincing proof that the shorter your film developing time, the longer the luminance set you were able to reproduce on a print. Print results of the sample tests, for example, were:

Development Time	Tones (Inclusive)	Printable Luminance Set
(D + 25%)	−2 to +2	5
(D)	−3 to +2	6
(D − 25%)	−3 to +3	7
(D − 50%)	−4 to +3	8

If your tests produced greater than one-number differences in printable sets, you can estimate the film development time required for a one-number increase by interpolation. On the other hand, if these 25% changes in development time did not change the number of printable steps from your negatives, you would have good reason to suspect faulty chemistry or equipment, or an error in calculation or in procedure.

Be certain to note that the (+) to (−) steps on your prints are not equal steps of grayness. Tone separation in the (+) values is greater than in the (−) values. This is due partly to the effects of film development time, and partly to a flare factor which is present in all lenses to some degree and which reduces tone differences mainly in the shadows. As significant, though, is our own inability to distinguish shadow tone differences in direct proportion to their density differences. (This matter is discussed more fully in Chapter 11.) *For this reason, you must refer to your test print to determine precise tonal differences of light-meter number values.*

Having made these preliminary observations, you can now assess the applicability of the system to your own photographic work.

The most direct application of your test data is in calculating exposure and film development time when your primary concern is *reproduction of a chosen scene range.*

Highlight

Shadow

In this case, you would make separate readings of what you chose to present as the highest detailed highlight and darkest detailed shadow, count the meter numbers encompassed by this span, and determine film exposure and film development time based on your test print data. To refer to the sample print results, for example, if a scene range included seven numbers ((−3) through (+3)), the highlight exposure would be increased by three stops over the highlight reading, and the film developed for 25% less than normal development time. The sample test print shows that this combination of (+3) highlight exposure and D−25% development time will provide the seven-value luminance set required. Since that seven-tone reference print indicates a shadow extreme of (−3), one could just as well have read the shadow and decreased exposure by three stops to arrive at the same result.

At this point you may question why one keys exposure on the (+) designation of a highlight, or the (−) designation of a shadow. After all, it seems to be measuring luminance extremes and splitting the difference. And if that is the case, since the compromise midpoint is (E), why not simply take along a gray card, read that, and set the camera aperture and speed accordingly? There are three reasons:

The first, of course, relates to film development. Unless you have read a selected highlight and shadow—determined the scene range—you would have no indication of proper film development time.

The second reason involves the artistic judgment you exercise when you select precisely which shall be the lightest meaningful highlight, and where shadow detail must end. The actual scene range, all elements considered, may be more than that seven number set. But by keying on the luminance levels you choose to place at the extremes of the print image capability, you determine interpretation of the scene. That control must not be arbitrarily surrendered to your meter.

And third: The readings provided by an averaging meter are not based on the luminance range alone, but are tempered by the *amount* of each particular luminance level present in the scene. For that reason, a scene that is essentially dark with some small brilliant highlights, or one that is bright with a few rich, expressive shadows, would be weighted incorrectly by the averaging of the meter.

Stated another way, important scene highlights and important scene shadows must be measured by you:

1. Because that is the only way you can get accurate, range-related film development data.
2. Because "important" highlights and shadows are your decision—your exercise of image control.
3. Because measurement of luminance levels must be made without their proportion of the total picture area affecting your readings.

A second application of your test data is in *placing the tone value of an object at a specific point in the gray scale,* simply by referring to your prints.

Let us assume that for the purpose of print contrast, you want to develop your film for the "normal" time. First refer to the print marked "Normal film development time," or "D."

If you wish to place the tone of the object at Ⓔ, simply aim your meter at it, and follow the exposure data the meter provides.

If, with snow for example, you prefer to place the object tone at ⊕2, aim your meter at the snow, and then increase exposure by two steps. Develop for your "normal" time.

If, when photographing a black cat, you choose to place its tonality at ⊖1 as shown on your test print, again aim the meter at the object—the cat—and reduce exposure by one step from your meter reading. Develop for your "normal" time.

Although the objects in the sample below have been placed at ⊕2 and ⊖1 , you have the option of selecting in-between tones. Simply adjust exposures by half-steps.

The most complete use you can make of your tests is in applying the results *in a studio situation* where, with full control of illumination, you are able to create a pre-chosen range. In addition, depending upon the type, number, intensity and direction of lights, specific objects in the scene can be placed at predetermined tone levels.

Suppose, for instance, you are photographing a box-shaped object and want to emphasize its three-dimension form by placing a different tonality on each of the three surfaces facing the camera. Referring to a specific tone control print, you can choose exactly the tone level you want for each of the planes, set up your lighting and verify it with your meter according to the plus, minus and (E) designations on the print, and achieve precisely those predetermined tones in your photograph.

There are occasions when you may choose to override the information in your tone control prints. One such condition might be a scene with a tremendously long luminance range. The shortened film development time required to include this total range in a printable negative may flatten the entire print image to the point where the reproduction—while a full range print—looks lifeless. Your alternative here would be to develop the film for a bit longer than your test prints indicate (to gain more contrast in the middle tones and highlights), with the foreknowledge that you will selectively burn in highlights when making the print.

At this point it is worth remembering that with film negative material, the total frame is usually exposed at one time, and development time is common to the total film.

It is only in the printmaking that *selected* areas of an image can be made lighter or darker; you change the tonal values in a particular part of the picture by dodging or burning in, techniques that may even include the use of variable contrast papers with a selection of appropriate filters used locally.

These techniques are based on an aesthetic judgment, and an important one. It is not intended that the photographic exactitude of tone control should inhibit this vital subjective activity.

Stated simply, tone control is capable of minimizing the need for dodging and burning in, compared with conventional printmaking. Still, as long as aesthetics extend into darkroom work, these tools will have a special value. They cannot substitute for controlled tone nor compensate for careless photographic technique. However, used constructively along with tone control, they may well allow you to add to a good photograph, your final personal touch.

● When creating a scale in highlight values, consider the option of half-steps, as well as full steps of tone difference between planes.

When the tonal value of the three planes are similar, the image seems flat (Fig. 1). By changing the placement of light, medium, and dark planes you create the illusion of depth (Fig. 2 through 7). Note also that although the object is the same in all the examples, the placement of particular highlight, medium and dark tones makes some of the boxes appear taller, or wider or longer than others.

The calculations required for most of your photographic work—perhaps as much as 90% of it—can probably be derived from your four basic test prints. But these prints are not meant to provide a static formula. It is your application of tone control—your adjustment of the system to your own subject, style and processing conditions—that will make it work creatively for you.

You may find that with your particular film, developer and technique, D−25% and D−50% create too radical a change in reproducible luminance range, and may opt for D—20% and D—40% instead. On the other hand, you may find that the print from the D+25% step tablet does not provide an adequate body of data for your kind of photography. If most of your work is photographed under short luminance range conditions, you may want to investigate the specific effect of D+50% or other films or developers.

Beyond these modifications, there may be occasions when you will have to deal with extreme conditions such as in:
— Photographing a luminance range that is *longer* than the one reproduced in the D−50% print.
— Photographing a luminance range that is *shorter* than the one reproduced in the D+25% print.

In both cases, changing paper contrast grade may help, and is a useful extra option in solving individual printing problems. But, varying contrast grades of paper can extend the flexibility of tone realignment only to a limited degree.

To deal predictably with a broad range of extreme conditions, you could increase the scope of your tone control data by further measured variations in film development. You do this simply by changing the dilution of your developer and running additional tests.

For example: To include a greater scene luminance range, the test exposures would be the same as those described in Chapter 4, with the four rolls developed for the same times as used previously but in *half strength* developer. This will allow you to gain additional paper response range data in terms of meter luminance numbers, without having to reduce film development times beyond those you have already established.

At the other extreme, to increase the effect of scene contrast in the print reproduction, the test could be run again with either longer developing time or a greater concentration of developer. Doubling the normal strength developer concentration is suggested. With this approach the resulting step tablets and their test prints would provide additional precise tone control information that would be permanently available for further experimentation and creative use.

If it is your decision to extend your print-making data by changing print papers rather than—or in addition to—altering developer strength, it is a good idea to make additional reference prints. Simply use the existing step tablets with the new papers precisely the way you did in running your original tests. Each additional set of prints will show you:

1. Which contrast grade of the new paper matches the grade of your original prints. Similar papers, exposed to the same tablet and using the same darkroom equipment and chemistry, produce the same response range (-3 to +2, for example), whether or not the manufacturer's contrast designation reads the same.

2. The difference in the shadow, middle-tone, or highlight contrast of one paper compared to another. This local contrast effect is the measure of tone difference between neighboring patches (-1 to E, for example) on separate print papers made with the same step tablet.

3. A comparison of tone color—warm, neutral, or cool—and where in the print scale this difference of tone color is most apparent.

4. The change in reproducible range possible with harder or softer paper contrast grades.

5. By using the same lens opening and magnification as for your original prints, and comparing exposure times, the relative difference in paper emulsion sensitivity, called paper speed.

Like film speed (ASA) ratings, paper speed designations are made in accordance with American National Standards Institute test procedures. This standard is ANSI PH 2.2-1966, *Sensitometry of Photographic Papers*. Since the objectives of using paper and film are different, the speed criteria and designations are not exactly inter-related. But the doubling system—twice the speed number means twice the sensitivity—still holds. A 16 speed paper, for example, requires one half the exposure time of an 8 speed paper.

In the chart of some ANSI paper speeds shown below, doubling intervals—indicating the effect of one lens stop changes—are listed above the line, with third-of-a-lens-stop differences in speed below the line.

Your relative paper speed computations using the step tablet aim point (E), are perhaps an even more accurate guide than the manufacturer's designation, because your tests are made under your unique darkroom conditions. However, the manufacturer's designated speed number accompanying your package of photographic paper provides a logical starting point for computing exposures for your comparative speed tests of papers.

The numbers cited in the table below are contact printing paper speeds. Enlarging paper speeds are often in the 100 to 500 range.

1			2			4			8			16			32	
1	1.2	1.6	2	2.5	3	4	5	6	8	10	12	16	20	25	32	etc

Summary:

1. Your prints indicate the film development times required for you to reproduce specific scene luminance ranges. Read the important highlight and shadow extremes in the scene, then compare the range to those shown in your prints.

2. By choosing any one of the prints and following its film development time, you assure placement on a chosen object of a specific tone in the gray scale. Aim your meter at the object, and adjust the exposure as your own print directs (⊕1), ⊕2, etc.).

3. There will be occasions when you will overrule the data in these prints, particularly when you choose to maintain a certain contrast in a print that will not allow all of the scene range to be reproduced. At this point you may elect to do selective dodging and burning in.

4. Although these test prints should cover a majority of the luminance ranges normally encountered, you may choose to increase your tone control data with further testing. The most useful test variations would be in film development time, or in developer concentration, to increase or reduce the printable scene range in terms of light meter numbers. Another, more limited possibility, is to make tests on low and high contrast grades of paper using your original tone control step tablets.

5. You are no longer bound by the word "average".

Making prints from each template on high, low and normal contrast grades of paper provides a somewhat broader scope of printable scene luminance ranges. This is a limited but useful option when conditions make it impossible for you to use more than one roll of film and all frames will receive the same development time.

It is evident that the Tone Control System can be used most easily with those cameras where development of a single film frame is possible (view cameras, for example). Some roll film cameras, however, offer interchangeable roll film backs. By using more than one back and labelling each with its intended film development time, it is possible for you to apply the Tone Control System very efficiently.

Should the development of single frames be impractical, and no interchangeable roll film backs available, a third option might be the use of separate camera bodies, each with the same type of film, but marked for a different development time.

In the event that you are restricted to the use of limited equipment—one 35mm camera, perhaps—it is still advantageous to use the Tone Control System. Additional pre-planning will be necessary, of course, so that the entire roll of film—all twenty or thirty-six frames—are exposed to the same scene range.

Such circumstances might be either in a studio situation, where with light, you control the scene range yourself, or outdoors in a setting that provides many possible subjects within a given range. In using such a camera, the quality of your prints need not be lessened, only the potential for impromptu shooting. And, until you can invest in additional equipment, you can be producing excellent prints and gaining invaluable experience.

Chapter 9
Effects of Scene Color

In the three chapters of this section, we will explore spectral sensitivity, a refinement of the Tone Control System which includes calculation of the effects of scene color on black and white film. We will also discuss some of the problems of illumination you encounter when exhibiting photographs. And finally, there will be an introduction to the field of densitometry, the fascinating study of density measurement that makes possible important and original work in the photographic field, and is the science behind the method of tone control.

The basic tone control testing procedure from which your exposure and development standards were derived, was based on photographing a constant color (white), and gathering different amounts of white light reflection onto the film. But, since scenes are seldom monochromatic, adjustments in your basic data are sometimes necessary to accommodate the color factor present in your photographic subjects.

The problem in making this accommodation begins with the fact that the tonal values of color as you perceive them are often different from the way your meter reads them, and both are different from the way your film responds to them.

For example, if you were to aim your meter at an 18% gray card to establish an (E) value, and then aim it at a *visually* equal-valued blue-green (cyan) object, the *meter* might read the cyan as (+1). Exposure of your *film* to both the gray card and the cyan object, and subsequent printmaking might result in:

Values	18% Gray	Cyan
Visual Judgment	(E)	(E)
Meter	(E)	(+1)
Print	(E)	(+2)

The cyan influenced the meter not only by its luminance but by its hue. Both meter and film were affected to a different degree and neither was precisely as you might have expected.

In addition, tests have shown that spectral sensitivity is often different from one brand of meter to another, and from one kind of panchromatic film to another.

Furthermore, no meter sensitivity exactly matches the color sensitivity of a specific panchromatic film even when color filters are used in an attempt to correct the color sensitivity of the material.

To summarize the elements of the problem:
1. Exposure meters and films are affected not only by the quantity of light, but also by its color.
2. The color sensitivity of a meter is different from the color sensitivity of film and both are different from the color perception of the human eye.
3. Color sensitivity varies from meter to meter.
4. Color sensitivity varies from film to film.
5. No meter can be matched to any specific film to achieve equal spectral sensitivity.

With so many variables in color response, it is obvious that there can be no blanket solution to color problems that will be valid in every case. No formula can substitute for concentration, experience, and patient, documented testing.

There are, nevertheless, three effective approaches to the problem, each suited to a different photographic situation:

If Your Scene Ranges From Black to White

In converting the total scene range to a film negative range compatible with your choice of photographic paper, your primary concern is with the extremes of scene highlights and scene shadows. Frequently these *are* monochromatic.

The very nature of deep shadows is that they are black and near black. This provides a reading compatible with the tone control test. At the other end of the scene range are the highlights. There, the aim point is often white or near white. When this is the case, you are actually dealing with a range of white highlights to black shadows; and meter, film and tone control data are compatible.

In this kind of situation, you can ignore the difference in spectral sensitivity between film and meter when calculating scene range.

If You Want to Place a Specific Gray Tone on a Colored Object or Aim Point

When, at the extreme of your scene range, there is a saturated color, or when you are photographing a single colored object (a green vase, for example), you have to amplify your basic test data in order to predict what adjustment in the meter reading would be necessary to make it compatible with the spectral response of your film. You can run one brief test, the results of which can be applied from then on with six commonly seen colors. This is the test:

Buy a 7″ Kodak Color Separation Guide from your camera store. It is Item No. Q-13, and is quite inexpensive. (Kodak also has a 14″ guide, their Q-14, but the small one is perfectly adequate for the test, and is easy to tuck in your camera case later.) Place it on an 18% gray reflectance card (outdoors, if that is where you do most of your photography, because the color of the illuminant will affect your results). Using a spot meter, establish your exposure, by aiming at the gray card. Then aim at each color on the guide which is printed on coated paper; you will be using these readings for comparison later. Be careful to avoid surface glare when using your meter and your camera. It would add tremendous density to your negative and nullify the test. Complete the open spaces at the top and in the second column of the small chart below:

Light source		Date	
Film			
Meter			
Gray Card Exposure	f/	@	Sec.

Color	Meter Value	Print Value	Print Difference
18% Gray	(E)	(E)	None
White			
Yellow			
Magenta			
Cyan			
Red			
Green			
Violet			

Photograph the gray card and color guide head on, being certain to provide for bellows extension factor, if applicable. Use a short enough exposure time to avoid reciprocity-failure effects. Develop your film normally. Then make a print on which your print's gray card tone value matches the actual card, and the color separation guide is reproduced in the same size as the guide itself. (This is done most simply by placing the card on the print easel and projecting the negative image over it, adjusting magnification until the two images, card and projected film negative, match in size.) This simplifies tone comparison later. Next, compare your print's "color values" to the tone control reference print which you designated "D" (for normal development time) and, based on an approximate match, allot the appropriate plus or minus number on your "color value" print, to each of the six colors. Then fill in the third column.

Next, compare the print designations in the print column (No. 3) with your meter designations column (No. 2). If they match, it indicates your choice of film "saw" the color as the same luminance as your particular meter. You will find, probably that your meter readings and your print values will not all match. For the sake of practicality, consider near matches as acceptable. Even then you will see definite differences in meter-vs-print values, caused by the spectral sensitivity and response of *your* meter and *your* choice of film. Note them in column 4.

Make a note on the face of the Kodak Color Separation Guide of the meter adjustment each color requires, and when photographing an object of similar color and saturation, adjust the exposure to compensate for it.

Let us assume, for example, that green read as (E) on the meter and was (-2) on the print. In that case, if you were photographing a green vase of approximately this color saturation, and wanted an (E) tonality in the vase, 18% gray on your print, you would increase exposure by 2 stops. (The balance of the set-up—background tone and scene range—should be prepared with this two-stop exposure increase in mind.)

Place the color separation guide on the 18% reflectance card and photograph them head on. Base the exposure on an (E) tone placement for the gray card.

If Your Subject Includes Many Colored Objects:

Outside the studio or when photographing several objects, each of a different color, the exposure compensation required to place one of the colors at a specific gray-value on the print may have an adverse effect on the others. When that is the case, another alternative should be considered. The use of a filter, or split-filter exposure (multiple exposure through a sequence of filters) is more appropriate.

To predict the effect of density shifts resulting from photographing through selected filters, run this test. After making the exposure to the 18% gray card and color guide as described above, use the balance of the test roll to shoot color-value negatives, each with a different color filter over the lens. (Include a small notation at the edge of the picture area in each exposure, indicating filter and filter-factor used. It should appear later, on your print). Then make a set of reference prints, each with the 18% gray card reproduction matching the actual card.

Last, compare the "color values" in each print to the original Kodak Color Separation Guide, to your meter readings, and to each other.

These reference prints should provide a measure of aid in predicting and altering tonal relationships when photographing multi-colored objects in the studio (product shots of colored packages with different color type, fabric prints, etc.) as well as outdoors in judging and controlling the reproduction tonal values of everything from grass to sky.

This series of tests is recommended not only for its unique application to the Photographic Tone Control System, but also because it provides a lot of practical information about color filters and their effect on the tonality of the film you use.

The results of sample tests are pictured on the following page, and will be more meaningful when examined with your Kodak Color Separation Guide at hand.

Conversion of Filter Factors to Increase In Exposure, In f-Stops:

Factor	Increase in f-stop
1.5	$\frac{2}{3}$
2	1
2.5	$1\frac{1}{3}$
4	2
5	$2\frac{1}{3}$
6	$2\frac{2}{3}$
8	3
12	$3\frac{2}{3}$

Kodak Gelatin Filters Recommended for This Test Are:

Designation	Color	Approximate Filter Factor (Plus-X Film) Daylight	Tungsten
8	Yellow	2	1.5
11	Yellow-Green	4	4
15	Deep Orange Yellow	2.5	1.5
25	Red	8	5
47	Blue	6	12
58	Green	6	6

Kodak Plus-X Pan Professional roll film was used for these samples. This is the resulting print when the guide was photographed without a filter over the camera lens.

black	3-color	white	cyan	violet	magenta	primary red	yellow	green

Photographed in daylight through a Kodak Wratten Filter No. 8, yellow.

black	3-color	white	cyan	violet	magenta	primary red	yellow	green

Photographed in daylight through a Kodak Wratten Filter No. 11, yellow-green

black	3-color	white	cyan	violet	magenta	primary red	yellow	green

Photographed in daylight through a Kodak Wratten Filter No. 15, deep orange-yellow

black	3-color	white	cyan	violet	magenta	primary red	yellow	green

Photographed in daylight through a Kodak Wratten Filter No. 25, red

black	3-color	white	cyan	violet	magenta	primary red	yellow	green

Photographed in daylight through a Kodak Wratten Filter No. 47, blue

black	3-color	white	cyan	violet	magenta	primary red	yellow	green

Photographed in daylight through a Kodak Wratten Filter No. 58, green

black	3-color	white	cyan	violet	magenta	primary red	yellow	green

Chapter 10
Exhibition Lighting

The Photographic Tone Control System concerns itself primarily with film exposure and development, and with printmaking. But, when photographs are made for exhibition, control will remain incomplete until consideration is given to the light conditions under which the prints are viewed.

There is no question that the quantity of illumination on a photograph radically affects it. To a point, the greater the illumination, the more you are able to see into the dark areas of the print. In addition to this greater shadow tone separation, high light levels add a feeling of crispness, contrast and brilliance. Beyond the optimum level, too much light seems to wash out the shadows and flare the highlights.

Unfortunately, there is no standard lighting level in which photographs are viewed, and occasionally the photographer makes prints that look great under his regular lighting conditions, and significantly less than great when he views them elsewhere. Obviously, this is a problem that should concern every photographer who cares about showing his work.

The first step in solving the problem might be to examine standards that have been set for analogous activities by professional organizations.

The American National Standards Institute has issued no directive regarding the light level for viewing prints on exhibition, but its Photographic Standards Board has arrived at a standard for printers and lithographers to follow when comparing photographic prints with their reproductions. The recommendation for photograph to printed halftone comparison is "2200 \pm 470 Lux" which converts to 204.4 \pm 43.6 footcandles, or roughly 200 footcandles.

The Photographic Society of America is an association of over 10,000 amateur and professional photographers whose objective is ". . . cooperative action in promoting the arts and sciences of photography and furthering public education therein . . ." Thousands of these members have participated in PSA accredited international photographic competitions throughout the world. Accreditation requires that the competition be held in accordance with PSA Uniform Practice No. 1: "Recommended Practice for Judging Black & White and Toned Prints." This very detailed set of regulations specifies that during *judging*, the level of illumination on the print plane should be 25 footcandles. There is no reference to lighting standards during the exhibition. (PSA illumination standard for color prints is 70 footcandles. In both cases, color temperature of the light, approximately 3000 K, is also specified.)

The Illuminating Engineering Society founded in 1906, is devoted exclusively to ". . . the advancement and dissemination of theoretical and practical knowledge of the science and art of illumination . . ." A section of their handbook contains a table based on scientific findings of the Illuminating Engineering Research Institute. It specifies *minimum* footcandles recommended for over a thousand locations, depending upon the tasks performed at those locations. The recommended illumination range runs from 0.1 footcandles (in theatre audience area during a show) to 2500 footcandles (hospital obstetrical suite delivery table).

From their list, the following five items have been noted here because they bear a kinship, in terms of their illumination needs, to print viewing.

Illumination for:	Footcandles
Art Galleries, dark paintings with fine detail	90 120
Viewing police identification records	150
Regular office work	100
Paint manufacture, comparing mix with standard	200
School: art classrooms	70

These ANSI, PSA and IES figures, tempered by personal on-site gallery readings, lead to the conclusion that a realistic standard would be 100 ± 25 footcandles with care to avoid glare off the print surface. This level of illumination for viewing prints is not inconsistent with the recommendation made earlier in accordance with ANSI findings that you examine your test prints in a light level of 200 footcandles. The higher level is required for exacting tone comparisons, while the 100 footcandle level is suitable for perception of tones as they relate to each other in a finished photograph, and is a practical standard for a gallery or museum.

● For a more definitive analysis of the
problems of measuring the precise
subjective effect of various light levels
on prints, the reader is directed to the
Mees text, listed among the references
for this chapter.

The difference between conditions as they ought to be and as they actually are is exemplified by the illumination present at exhibitions of black and white prints even at prestigious galleries and museums. Readings taken at the Museum of Modern Art in New York showed light levels from 16 to 100 footcandles; and at the George Eastman House in Rochester, New York, 32 footcandles.

Should you be preparing to make prints for exhibition at a specific location, it would be wise to determine the level of illumination at that location. Then, either adjust that illumination to meet your standard, or adjust your standard by examining your prints in the specific "exhibition illumination level" to determine their adequacy.

Although special footcandle meters are available, some instruction books that are provided with conventional exposure meters have charts for converting meter readings to approximate footcandle figures. The Gossen Luna-Pro has such a table affixed to the back of the meter itself. If you do not have such a chart, you can determine approximate footcandles this way:

Set your meter for *incident* measurement with ASA at 100, and place it so that the receptor is facing the same direction as the print surface does. Take a reading and determine the recommended lens opening for an exposure time of $\frac{1}{8}$ second. Convert to footcandles by the formula that follows:

⅛ Second at:	Footcandles
f/2	8
f/2.8	16
f/4	32
f/5.6	65
f/8	130
f/11	260
f/16	500
f/22	1000

There are many complex considerations in illumination-standard-setting that have not been mentioned in this brief exposition. To study the subject in depth would involve a catalogue of factors which would include such things as color temperature as well as intensity of light, direction of light source and its kind (spot, flood, indirect or diffused), color of surrounding walls and viewing distance.

It is not within the purview of this book to explore all these considerations. But, since illumination markedly affects the
● subjective range and detail of a print, it is hoped that a growing awareness among photographers and exhibitors will help to direct toward this problem the kind of attention it requires.

Chapter 11
Densitometry

Throughout this book, we have referred to the term density. All the test procedures of the Tone Control System have been directed toward determining, within the framework of your personal scene interpretation, darkroom conditions and working methods, the precise negative density range to which your photographic paper responds.

Basic to the system is the study of density measurement, densitometry. As you read this chapter, referring to the charts and graphs it includes, you will gain—along with the practical data your tests have provided—an understanding of how the variables in the photographic process relate to each other and how you can manipulate them to extend and refine your work. And you will learn how to coordinate the levels of reflected light in a scene with the tonal scale in each of your prints.

The measurement and charting of print density in relation to scene luminance allows you to see graphically what visual changes occur, where neighboring tones gain or lose definition, for instance, when you change film exposure or development time. You see why, as you have already observed in conducting your tests, to gain one photographic advantage you may have to sacrifice another, such as giving up tone contrast between close grays at some part of the scale when you want to include a very long scene luminance range. Densitometry makes it possible for you to seize every advantage within the scope of your materials and methods, and to do so with a minimum of sacrifice and no guesswork.

We can best begin this densitometric study by directing our attention to the film negative and the characteristic called transmittance. Transmittance denotes that part of light which passes through the film, and is always expressed as a percentage or as a fraction of the light directed at it. Example: You direct four units of light at the negative; two units of light pass through it; transmittance is $2:4$, or $\frac{1}{2}$, or 50%.

But, in dealing with the transmittances of a negative, the fractions or the percentages are difficult to relate to each other over a span of more than a few numbers. The relationship of $\frac{1}{2}$ to $\frac{1}{32}$ or of 50% to 3.1% is not all that easy to deal with, in the context of the "halving sequence" common to meters, lens apertures, and shutter speeds.

So, a second method of stating the characteristic of transmittance might be considered: opacity. Opacity is the inverse of transmittance: the transmittance fraction inverted. For example, if a given negative transmittance is $\frac{1}{2}$, its inverse is $\frac{2}{1}$, indicating that in order for one unit of light to be transmitted by this negative area, it must be illuminated with two units of light.

Opacity of a negative, then, relates to the number of units of light that it must receive in order to transmit one unit of light.

The Transmittance No.	1	$\frac{1}{2}$	$\frac{1}{4}$	$\frac{1}{8}$
Mean an Opacity of:	1	2	4	8

Still, relationships are difficult to see, since the intervals between sequential opacity numbers are not constant ($2 - 1 = 1$, $8 - 4 = 4$). So, a more practical system was arrived at; the term for this system of tone designation is *density*. Density is opacity expressed as a logarithm. The logs of sequential opacities (in the doubling intervals we use in photography) are easily related; they progress in constant arithmetic intervals. Here is how the method works:

What we call fifty percent transmittance in photography is expressed fractionally as a transmittance of $\frac{1}{2}$. That is equivalent to an opacity of 2. And the log of $2 = 0.3$. Twenty-five percent transmittance, or transmittance of $\frac{1}{4}$ is equivalent to an opacity of 4. The log of $4 = 0.6$. Twelve-and-a-half percent transmittance equals $\frac{1}{8}$ transmittance or opacity of 8. The log of $8 = 0.9$. How is this density factor put to use? Each time you wish to reduce a light transmission or reflection by half, you have available a constant halving number: 0.3 density. Each 0.3 neutral density filter placed over the lens, for example, reduces exposure the equivalent of one lens stop.

● In exposing the test film, in order to affect smaller lens apertures than the camera provided, we used neutral density filters; each 0:3 N.D. filter reduced the light by half, with an effect equivalent to closing down the lens opening by one f-stop.

Assembling a more complete chart, then, we have:

Negative Transmittance Percentage:	100%	50%	25%	12.5%
Negative Transmittance Fraction:	1	$\frac{1}{2}$	$\frac{1}{4}$	$\frac{1}{8}$
Opacity:	1	2	4	8
Density	0.00	0.30	0.60	0.90
	└.30┘	└.30┘	└.30┘	

Logs are often expressed in four figures after the decimal. For example: Density 0.3010, 0.6021, 0.9031. But for most photographic purposes, one or two figures after the decimal are adequate.

When we talked about print tones, we referred to a mid-tone gray as an 18% reflectance value. Reflectance of an object (in this case, an area of the print) refers to the light which is reflected from its surface and is expressed as a percentage or fraction of the light directed upon it.

For photographic prints then, we can prepare a similar table:

Print Reflectance Percentage:	100%	50%	25%	12.5%
Print Reflectance Fraction:	1	$\frac{1}{2}$	$\frac{1}{4}$	$\frac{1}{8}$
Print Reflectance Fraction Inverted*:	1	2	4	8
Print Density:	0.00	0.30	0.60	0.90
	└.30┘	└.30┘	└.30┘	

*There is no term for a print equivalent to opacity for a negative.

Now, we can go back to some of our earlier observations and extend them a bit.

When we discussed exposure meters, the statement was made that each number on the dial indicates a luminance that is twice its next lower number. Another way of stating the same fact is that *each number on the dial indicates a luminance that is $\frac{1}{2}$ its next higher number.* If we were to begin with a dial reading of 16, for example, and call it 100%, or 1, we could make up this table of relative luminances:

Meter:	16	15	14	13
Relative Luminance in Percentage:	100%	50%	25%	12.5%
Relative Luminance Fraction:	1	$\frac{1}{2}$	$\frac{1}{4}$	$\frac{1}{8}$

When we talked about lens openings, we said that each successive lens setting on your camera signifies the aperture is allowing twice as much light to pass through the lens in a given time period. Another way of stating the same fact is: *each successively smaller lens opening on your camera signifies the aperture is allowing $\frac{1}{2}$ as much light to pass through the lens* in a given time period.

If we were to begin with a lens opening of f/1.0, for example, we could create this table:

Transmittance Percentage:	100%	50%	25%	12.5%
Transmittance Fraction:	1	$\frac{1}{2}$	$\frac{1}{4}$	$\frac{1}{8}$
Lens f-Stop:	1	1.4	2	2.8

There is an introductory workbook on the subject of sensitometry and densitometry published by Kodak. After reading it, should you choose to dig still deeper, refer to *Photographic Sensitometry,* Todd & Zakia, Morgan & Morgan, Publishers, Dobbs Ferry, New York, Second Edition 1974. For historical reference *only,* see the facsimile edition of *The Photographic Researches of Ferdinand Hurter & Vero C. Driffield,* published by Morgan & Morgan, Dobbs Ferry, New York, First Edition 1974.

We also indicated that shutter speeds provide a doubling sequence on most cameras. If we were to begin with a shutter speed of 1 second, for example, we could create this table:

Time as Percentage:	100%	50%	25%	12.5%
Time Fraction:	1	$\frac{1}{2}$	$\frac{1}{4}$	$\frac{1}{8}$
Shutter:	1	$\frac{1}{2}$	$\frac{1}{4}$	$\frac{1}{8}$

To assemble all this information in one table, the halving intervals could be shown this way:

Meter, Scene, Camera

Meter:	16	15	14	13
Luminance Percentage:	100%	50%	25%	12.5%
Luminance as a Fraction:	1	$\frac{1}{2}$	$\frac{1}{4}$	$\frac{1}{8}$
Lens:	1	1.4	2.0	2.8
Shutter:	1	$\frac{1}{2}$	$\frac{1}{4}$	$\frac{1}{8}$
Equivalent Neutral Density:	**0.0**	**0.3**	**0.6**	**0.9**

The Negative

Transmittance:	100%	50%	25%	12.5%
Transmittance as a Fraction:	1	$\frac{1}{2}$	$\frac{1}{4}$	$\frac{1}{8}$
Opacity:	1	2	4	8
Density:	**0.0**	**0.3**	**0.6**	**0.9**

The Print

Reflectance:	100%	50%	25%	12.5%
Reflectance as a Fraction:	1	$\frac{1}{2}$	$\frac{1}{4}$	$\frac{1}{8}$
Inverse of Print Reflectance:	1	2	4	8
Density:	**0.0**	**0.3**	**0.6**	**0.9**

Density, then, is an easy-to-handle index of light in its relation to reflectant materials (prints) and transparent materials (negatives, transparencies and filters). Each 0.3 density indicates a reduction in reflectance, or reduction in transmittance by $\frac{1}{2}$.

Densitometric determination of the degree of light absorbing capability in a negative or on a print is most precisely accomplished using electronic densitometers. These devices feed out a measured quantity of light, measure the amount reflected from a print (reflection densitometer) or transmitted through a film (transmission densitometer) and convert the fraction of reflection or transmission to a density value. An electronic densitometer removes measurement from the area of opinion regarding tone matches and relationships and allots a specific number in density units to each tone value.

Such densitometers, however, are very expensive. A more realistic approach for you may be to sacrifice the impartiality and exactitude of an electronic reflection densitometer (when analyzing your test prints) for the practicality of a visual-match scale.

▲ A sample of Tone Reproduction Graph paper appears on page 80.

This guide will help you approximate the density of each tone area in your test prints.

If your budget is modest, your print densities can be approximated by comparing them to the patches on a Kodak Reflection Density Guide (Publication Q-16). This is an 8″ x 10″ rigid card containing a calibrated, 24-step photographic gray scale with a density range of 0.00 to 2.00. There is a punched-out hole through each tone, so that you can use the guide in the same way as you were directed to use the 18% spotter you made earlier. You will find it works well as an inexpensive visual reference in the application of the Tone Control System. It can be obtained at graphic arts and photographic supply houses, or directly from the Eastman Kodak Company, 343 State Street, Rochester, N.Y. 14650.

One more thing you will need to chart your observations is a supply of Tone Reproduction Graph Paper obtainable by mail from the Graphic Arts Research Center, Rochester Institute of Technology, One Lomb Memorial Drive, Rochester, N.Y. 14623. Write for their catalog.
▲ This is item 3 043 10.

It is worth mentioning at this point that the logarithmic designation of density is used because in addition to simplifying opacity relationships and being most compatible with emulsion response, it *comes closest* to the manner in which the eye sees tone comparisons. All too often, this is misunderstood to imply that equal differences in density will exactly equal visual differences in gray steps. It isn't quite so. As a comparison, *The Munsell Color System* of values, which is spaced in *equal visual gray tonal steps*, is presented below along with densitometric measurements of the same values.

Kodak REFLECTION DENSITY GUIDE

(24-STEP)

Printed numbers below the density patches refer to established density readings of the patches. See back of guide for further explanation. To use the guide as a densitometer:
1. Through the holes, locate the area to be read and determine the density values.
2. Maintain contact with the reflection copy being measured.

| 0.0 | .05 | .10 | .15 | .20 | .25 | .30 | .40 |

| .50 | .60 | .70 | .80 | .90 | 1.00 | 1.10 | 1.20 |

| 1.30 | 1.40 | 1.50 | 1.60 | 1.70 | 1.80 | 1.90 | 2.00 |

T.M. Reg. U.S. Pat. Off. © 1970, Eastman Kodak Company

Munsell Value	Density	Density Span
10	0.00	
		0.12
9	0.12	
		0.12
8	0.24	
		0.14
7	0.38	
		0.15
6	0.53	
		0.19
5	0.72	
		0.21
4	0.93	
		0.26
3	1.19	
		0.33
2	1.52	
		0.41
1	1.93	

Sometimes this concept is easier to visualize when presented graphically. If equal differences in density created equal visual steps of gray, the curve (representing Munsell steps in terms of density) would fall exactly on the diagonal line.

This curve on conventional graph paper shows how the density of the middle-tones and shadows of the Munsell scale increases radically in order to appear as equal visual steps of gray.

The density differences, which are fairly consistent about ⅓ of the way down the scale, become significantly wider apart in the shadows. This indicates that *a given densitometer unit spread in the shadows represents nowhere near the visual tonal change that a similar spread would show in the highlight values.* An interesting and simple way to reconcile these differences is inherent in the charting procedure that will be used to record and analyze densitometric data from your own test prints.

Practical Applications of Densitometry

A. Plot your test print curves on the Tone Reproduction Graph paper.

1. *Familiarize yourself with the graph paper.*

a. Density markings derived from scene luminance appear at the base of this graph. Density notations indicated along the left side of the graph, running vertically, represent test print tones. On this graph you can plot the simulated luminances to which your test film was exposed, coordinated with the resultant densities in the print you produced.

b. Note that the values rather than being spaced in equal density increments, are spaced in *equal visual steps,* as indicated by the equally spaced dots along the top and right side of the chart. Each dot represents a Munsell value, and the density of that value can be read by referring to the density designations at the opposite side of the graph.

By placing the Munsell dots at equal intervals, and assigning the specific density value each one represents, we create a framework on which can be placed a reproduction curve that closely resembles visual response to both the scene and the print tones. Spaces between dots have been marked off with appropriate equivalent densities; and where space permits, the areas between dots are drawn in, in greater detail. This consideration of visual effect provided by the Munsell scale is important in creating a meaningful reproduction of your data . . . conventional graph paper would provide technically correct, visually misleading curve structures by shifting the emphasis of your data. Note again how the density values are placed closer together as the chart extends from left to right—from highlight to shadows—because we are less visually sensitive to density differences in the dark areas of a scene and a print. (A density span of 0.12 in the highlight occupies as much length as a 0.41 span in the shadows.)

TR
Graph paper

The Tone Reproduction Graph is a graphic arts aid. To chart photographic tone control data, the words "Density of Original" must be changed by you to "Metered Tone Control Value," and "Density of Reproduction" to "Print Density," as shown here.

Reproduced with permission from the Graphic Arts Research Center, Rochester Institute of Technology.

Print Density

Metered Tone Control Value

The chart below shows how evenly spaced visual gray values (Munsell Color System) relate to the one-number intervals on your light meter scale. Notice the lack of visual *shadow* tone separation.

Munsell									
10	9	8	7	6	5	4	3	2	1

Meter*	(+2)		(+1)		(E)	(−1)	(−2)	(−3)	(−4)

* Meter readings converted to Tone Control designations.

This indicates that if shadow tone separation is particularly important, (as in many long luminance-range scenes) the film should be "overexposed" at least one stop. You will observe, when you graph your test prints, that this will place shadow values on the slope (mid-section) of the curve where density differences are greater. To avoid compromising other values, you then underdevelop the film 25% to 50% to limit highlight contrast and reduce overall film density range.

c. Note that the highlight end of the scale is at the left, the shadow to the right; and highlights in your print will record near the base of the grade, and shadows toward the top. This configuration of curve—highlights low and at the left, shadows high and at the right—may seem contrary to conventional graphs you have seen. The reason for this is that normally the graphing procedure relates exposure to *film* response. As density increases in the film *negative* (indicating scene highlight) the curve moves upward. But when we concern ourselves with *prints,* increasing density indicates scene shadow. Still, if it is easier for you to visualize the shadows of the curve low and

at the left, and highlights high and to the right, simply invert your completed graph. Your ability to understand your data is more important than adhering to a general style.

2. *Prepare your chart:*

a. Look at the density numbers marked along the bottom of the chart representing scene luminance levels. Mark the 0.74 with the symbol (E) as shown in the sample. (E) signified 18% reflectance in our
▲ test print scene, and its equivalent density is 0.74.

b. Mark the (+) and (−) steps by spacing each one 0.30 from its neighbor. (0.30 is a halving or doubling interval, equivalent to your one lens stop changes during your test). To the left of (E) are the successively lighter tone levels in the simulated scene, to the right are the darker ones. Note that after marking off 0.44 ((+1)) and 0.14 ((+2)) you reach the left end of the chart. This indicates that 100% reflectance is at approximately plus (2½) and would be the upper limit in a normal scene. Since secondary light sources or the inclusion of the illuminant in your picture could provide a higher value than (2½) the chart would indicate an unusual light condition, and show you how your print responded to it.

c. On the left margin of the graph, mark with a dot the position of 0.74 density. Our tests have been keyed to this 18% reflection gray print tone.

d. Draw a diagonal from the lower left corner to the upper right. (It is Item A on the graph illustration.) All your data that fall on this line indicate print tones precisely matched to their scene luminance values.

3. *Collect your data and plot them on the chart:*

a. Start with your D print, made from your normally developed negatives. With 200 footcandles of illumination at the viewing surface, examine each tone patch on the print for a match to one on the Kodak Reflection Density Guide. Allot to each print tone, the appropriate density value as specified on the guide.

b. Transfer those data to the chart. Mark the print density of your Ⓔ patch first. It will be close to 0.74 and should be marked on the graph where the horizontal axis at that level intersects the Ⓔ vertical axis similarly marked at the base. Next, transfer the rest of the print data in the same manner. Last, connect the dots smoothly; you will have created the tone reproduction curve. Label the curve with its appropriate film development time (in this case, D).

c. Plot the curves of the remaining test prints, using a different color of ink or pencil for each.

● Approximately 200 footcandles may be provided by a 100W incandescent bulb in a 10″ reflector 30″ from the viewing surface.

▲ Refer to the graph on the following page as you read.

B. *Analyze your "Normal" Print curve:*

If, the curve of your *normal* film development print does not remain reasonably close to the diagonal, the shape of the curve will show whether further refinement of your data requires a modification of your basic exposure index, or basic development time, or both. Necessary corrections will depend upon the area in the graph toward which your curve deviates. Specifically:

▲ If plotted points are too far from the diagonal and are in area B, the highlight values in your test print are too dark in relation to the simulated scene. To create lighter values in the highlights, your negative representing this area should be denser. The remedy: increase film development time because such increased development has its greatest effect in the highlight region of your film.

If plotted points are too far into area C, the highlight values in your test print are too light in relation to the balance of the simulated scene. To create darker highlights without materially affecting the balance of the curve, your negative in this area should be less dense. The remedy: reduce your film development time.

If plotted points veer too far from the diagonal and are in area D, the shadow values in the test print are too dark in relation to the simulated scene. To place them closer to the diagonal line would require more density in your negatives in the shadow values. The remedy: reduce your film Exposure Index.

TR
Graph paper

A. All values in the print that plot on this diagonal line are in *exact tonal ratio* to the original scene. The test print curve which most closely approximates the line indicates what should be considered your *normal* film development time.
B. Highlight end of scale.
C. Highlight end of scale.
D. Shadow end of scale.
E. Aim point of the system: 18% reflectance. Density 0.74.
F. Shadow end of scale.
G. This side of the diagonal: The print is darker than the scene value.
H. This side of the diagonal: The print is lighter than the scene value.

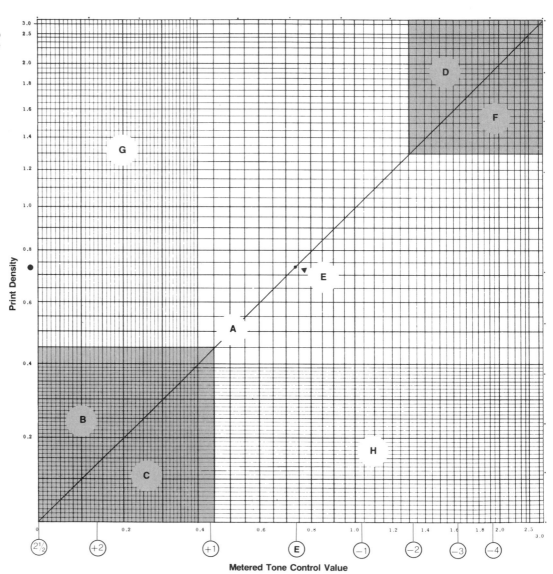

If plotted points deviate too far into area F, the shadow values in the test print are not dark enough in relation to the simulated scene. In other words, the shadow film densities are too great, and should be thinner. The remedy: increase your
● film Exposure Index.

Since the shadow tones in the print are determined by their difference in negative density from the (E) patch, significant changes in (E) patch film density could affect the shadow curve shape. For this reason, the suggested remedies that involve a change in Exposure Index are only applicable when the film, specifically the (E) patch, has received normal or nearly-normal development.

Of course, highlight values may be affected by more than film development time alone: developer strength, composition, temperature, contamination, and agitation are just a few of the other possibilities. And shadow values may be affected by the accuracy of your particular meter, the accuracy of your camera shutter speeds and f-stop settings, and by flare, and the age and storage conditions of the unexposed film. But assuming a reasonable amount of care and precision in conducting your tests, and equipment and materials appropriate for the project, the remedies suggested above are accurate and helpful.

C. *Study additional information provided by the graph.* Translating each of your four prints into a separate curve on a single graph shows you:

1. The density range of each print.

2. A comparison of the contrast in the shadows, the middle tones, and the highlights. The steepness of curve incline is a graphic picture of how each print compares to the others in this vital factor. If the curve is steeper than the reference line, the print has more contrast than the subject. If the curve is flatter—less steep—the print has less contrast than the original.

 Note: It is rare to find a curve that exactly matches the reference line. You may well find that the curve for a print *you* consider excellent departs from the straight line. In that case, use the curve for an excellent print in the future to test the success of your process.

3. The area of major change when film development time is increased. It is in the contrast in the lighter half of the scale.

4. The contrast of neighboring values and how it is effected by development time. The shorter the film development time, the less marked the neighboring tone step-offs.

5. Where in the scale these neighboring tonal step-offs are sacrificed most when you shorten development time to include a greater scene luminance span. The lighter half of the scale again.

D. *Add to Your Densitometric Data*

1. By changing film (re-running the test with a faster or slower film emulsion), or by using the same type of film and substituting another developer, or by using one step tablet and making prints on various brands, finishes, or contrast grades of paper, you could produce valuable additional information to chart. The precise effect on local and total contrast would be exhibited by a comparison of the new test print curves against your original ones.

 Total contrast is shown by the vertical difference between the extreme ends of the graph. If the scene luminance range is large, the print will necessarily have a lower total contrast than the scene. Local contrast is shown by the steepness of the curve.

2. Similarly, beginning with a negative step tablet with known density increments (such as a Kodak Photographic Step Tablet No. 2, with density increments of 0.15) and printing it through your enlarger on several contrast grades of paper, you would be able to determine, by counting the number of steps in which tonal change appears in a print, the density range of negative that is compatible with each contrast grade of paper. Then, by plotting each on the graph, you could see where in the scale contrast is altered when you switch from one contrast grade to another.

 A print that showed 6 steps of the tablet in this test would be responding to a negative density range of 0.90 ($0.15 \times 6 = 0.9$). Softer papers, (grade 0, and 1) would respond to longer range negatives (1.10 for example.) If you have a thin negative, and attempt to salvage the image, its short range (0.6) might allow the negative to be reproduced as a full range print on one of the harder (higher number) contrast grades which has a short response range.

 Should you be fortunate enough to have access to a transmission densitometer, you could run this test to determine which grade reproduces a specific negative density, then simply read the range of each of your negatives to determine a logical paper grade starting point in your print-making.

This chapter on densitometry cannot offer a comprehensive exploration of the field. It is intended simply as an introduction to a subject that is too often regarded as formidable, abstract and theoretical, but which is actually both accessible and practical. With the knowledge you now have, you can understand the extent to which densitometry has contributed to technological progress in the photographic field, and recognize it as the cornerstone of all tone control. The more deeply you pursue its possibilities, the more answers you can find to the inevitable questions that arise in the pursuit of your personal vision.

The Photographic Tone Control System is not a magic formula; it is an approach to quality craftsmanship. It frees the time and creative energy you might otherwise spend in trial-and-error experimentation for productive use behind the camera or in the darkroom. The customized reference source provided by your own documented tests is your key to creative freedom. It affords you the technical mastery to realize your vision and communicate your subjective interpretation.

Technical virtuosity is not achieved overnight; like insight and artistry, it takes time to mature. But disciplined testing and systematic recording of results will shorten the journey between your inspiration and its realization. That is what the Photographic Tone Control System is all about.

Appendix

I. Reciprocity Effect

Reciprocity (The Bunsen Roscoe Law): The same density will always be obtained when the product of illumination and exposure time remains constant. The law and its failure are more easily explained by the following examples:
100 one-ounce bottles of developer are equivalent in volume to one 100-ounce bottle, or 50 two-ounce bottles, etc. This demonstrates a reciprocal relationship.

By the same reasoning you might expect 100 units of light for a one second duration to be equivalent in effect to one unit of light exposed to the film for 100 seconds duration. Not so. Film loses some of its proportional response to light with very long or very short exposure times. For this reason, if your exposure meter indicated a 10 second exposure was required with Plus-X film, the film should actually be exposed not for 10 seconds, but for 50 seconds, (and then development time reduced by 20% to control contrast changes caused by this long exposure). This phenomenon is called "the failure of the law of reciprocity" (The Schwarzchild Effect). All film is subject to this failure to some degree, and film manufacturers distribute literature with exposure and development recommendations to compensate for this effect. *You* must make the adjustment. Your luminance meter dials do not indicate the additional exposure required to adjust for reciprocity failure effects.

The following chart shows reciprocity-effect adjustments for the more commonly used Kodak professional black-and-white films. It is taken from Kodak Publication No. 0-2, dated November, 1974, and Publication F-5, dated December, 1976.

For a comprehensive explanation of reciprocity failure and other exposure effects, see *Photographic Sensitometry,* 2nd edition by H. N. Todd and R. D. Zakia, Morgan & Morgan, Inc., 1974.

KODAK Professional Black-and-White Films Reciprocity Effect Adjustments

For the following KODAK Films:

EKTAPAN 4162 (ESTAR Thick base)*
PANATOMIC-X
PANATOMIC-X Professional
PLUS-X Pan
PLUS-X Pan Professional
PLUS-X Pan Professional 2147 (ESTAR Base)
PLUS-X Pan Professional 4147 (ESTAR Thick Base)
PLUS-X Portrait 5068

ROYAL Pan 4141 (ESTAR Thick Base)
ROYAL-X Pan 4166 (ESTAR Thick Base)
ROYAL-X Pan
SUPER-XX Pan 4142 (ESTAR Thick Base)
TRI-X Pan Professional
TRI-X Pan Professional 4164
(ESTAR Thick Base)

*KODAK EKTAPAN Film 4162 (ESTAR Thick Base) does not require a development time adjustment for exposures of 1/1000 second.

If Indicated Exposure Time (sec.) is:	Either Adjust Lens Aperture:	Or Adjust Exposure Time:	And in Either Case, Develop Film:
1/100,000	1 stop more	Use Aperture Change	20% more
1/10,000	½ stop more	Use Aperture Change	15% more
1/1,000	None	None	10% more*
1/100	None	None	None
1/10	None	None	None
1	1 stop more	2	10% less
10	2 stops more	50	20% less
100	3 stops more	1200	30% less

For the following KODAK Commercial Films:

Commercial 4127 (ESTAR Thick Base) Commercial 6127

If Indicated Exposure Time (sec.) is:	Either Adjust Lens Aperture	Or Adjust Exposure Time	And in Either Case, Develop Film:
1/100	None	None	10% more
1/25	None	None	Normal
1/10	None	None	10% less
1	None	None	20% less
10	½ stop more	15	30% less
100	1 stop more	300	40% less

II. How to Use a Spot Meter for Incident Readings

A spot meter is a specialized piece of equipment; very useful in the application of the Photographic Tone Control System. Yet, there are occasions when spot meter readings are not possible or practical, or when readings would be more relevant when evaluated along with an incident reading. At such times, in the studio or on location, the photographer has the option of taking along a Kodak Neutral Test Card (18% reflectance) as a target for equivalent incident readings, or using another meter altogether. This can be cumbersome, inconvenient, and time-consuming.

This is how to avoid these disadvantages:

Cut a disc the diameter of the inside of the spot meter lens cap from a Kodak Neutral Test Card, peel off the mounting board at the back, and insert it into the cap.

To take an incident reading, since the meter reads 1° or so, hold the cap at about arm's length aiming the inside of the cap in the same direction as you would a flat-surface-incident meter, and read the inside-the-cap gray patch sample with the spot-meter. That's all.

There is no need to hunt around for a misplaced Test Card, or to refer to another meter. Since the cap is replaced when not in use, the gray value inside the cap remains clean and reliable. Should it become soiled, it is easy to replace.

In addition, a cap that can be stood on end could be placed as much as 5 feet from a 1° meter, and still provide accurate incident-equivalent readings. This is particularly useful in the studio where small product photography is done.

Last, the sample is a readily available visual reference of \textcircled{E} when evaluating and comparing subject luminance, a vital element of tone control.

Kodak Neutral Test Card

Meter Lens Cap

III. A Method of Making Films of Different Speeds Compatible

● Just as in this country the sensitivity of photographic materials is designated according to ASA specifications, (Plus-X, ASA 125 for example), Germany's materials are DIN rated (Deutsche Industrie Norm).

There is a quick and easy way to determine the neutral density filtration that would be required to permit two films of dissimilar speeds to be exposed using the same shutter speed and lens opening.

A. First, convert the American speed rating
● (ASA or E.I.) of each film to DIN rating.

B. Then, subtract one DIN rating from the other and divide by 10. That is the filtration the faster film requires to make it compatible with the slower one.

Most film packages and exposure meters indicate both ASA and DIN ratings. Should that information not be available, the conversion table is listed below:

ASA (E.I.)	DIN	ASA (E.I.)	DIN
12	12	340	26
16	13	400	27
20	14	500	28
25	15	680	29
32	16	800	30
40	17	1000	31
50	18	1250	32
64	19	1600	33
80	20	2000	34
100	21	2500	35
125	22	3200	36
160	23	4000	37
200	24	5000	38
250	25		

Example 1

Faster Film: Kodak Tri-X: ASA 400
Slower Film: Kodak Plus-X: ASA 125

ASA 400 = DIN 27
ASA 125 = DIN 22

$27 - 22 = 5$
$5 \div 10 = .5$

Use of .5 N.D. filtration with Tri-X film allows you to use the same camera settings as with Plus-X film.

Example 2

Faster Film: Polaroid Type 107 EI 3000
Slower Film: Kodak Plus-X Prof ASA 125

E.I. 3000 = DIN 36 (closest rating)
ASA 125 = DIN 22

$36 - 22 = 14$
$14 \div 10 = 1.4$

Therefore, to expose Polaroid Type 107 film at the same shutter speed and lens opening as Plus-X film, place a 1.4 N.D. filter over the lens when shooting the Polaroid Type 107.

Example 3

Faster Film: Polaroid Type 107 EI 3000
Slower Film: Panatomic-X: ASA 32

E.I. 3000 = DIN 36
ASA 32 = DIN 16

$36 - 16 = 20$
$20 \div 10 = 2.0$

Use 2.0 N.D. with Polaroid Type 107

IV. Practical Angle of Coverage of Camera Lenses

Since the image projected on the film plane by a lens is circular, and film format is a rectangle within that circle, it is a common practice to compute the angle of coverage of a given lens in relation to the diagonal of the film format: a measurement akin to the diameter of the circular image. (See Figure 1)

From a practical standpoint, though, the horizon line in a photograph is rarely diagonal in the print, and so the conventionally designated angle of view is misleading. More meaningful is the angle computed on a horizontal line within the film frame (See Figure 2). This provides a more realistic measurement, more useful in comparing lenses of various formats.

The following chart is based on this more practical approach: the horizontal angle of view of various lenses. (It appeared in the July, 1975 issue of "Photographic Business and Product News".)

Fig. 1

Fig. 2

Wide Angle to "Normal" Lens

Horizontal Angle of Coverage	35mm (24x36)	2¼x2¼ (55x55)	6x7 (55x69)	4x5 (98x120)	5x7 (123x170)
			Camera Format		
100°	**15mm**	23mm	29mm	50mm	71mm
97°	16	24.5	31	53	**75**
93°	17	26	33	57	80
90°	**18**	27.5	34.5	60	85
87°	19	29	36.5	63.5	**90**
85°	19.5	30	37	**65**	92
84°	**20**	31	38	67	94
81°	**21**	32	40	70	99
77°	22.5	34	43	**75**	106
74°	**24**	37	46	80	113
72°	**25**	**30**	48	83	117
69°	26	**40**	**50**	87	124
67°	27	41	52	**90**	127
65°	**28**	43	54	93	132
64°12′	28.6	43.8	**55**	95.6	135
62°	30	46	**58**	101	143
59°	32	48.5	61	106	**150**
57.5°	33	**50**	63	109	154
56°	34	52	**65**	113	160
54°	**35**	54	68	117	**165**
53°	36	**55**	69	**120**	170
50°34′	38	58	73	**127**	178
49°	39	**60**	**75**	130	185
48°	40.5	62	78	**135**	191
46°	42.5	**65**	81.5	142	201
45°26′	43	65.7	82.4	143	203
44°	44.5	67.9	85.2	148	210
43°36′	**45**	70	86	**150**	212.5
42°18′	46.5	71	89	155	219
42°	47	72	**90**	156	222
40°	49	**75**	94	164	232
39°36′	**50**	76	96	167	236
38°54′	51	77.8	97.6	169.7	240.5

"Normal" to Telephoto lens

Horizontal Angle of Coverage	Camera Format				
	35mm (24x36)	2¼x2¼ (55x55)	6x7 (55x69)	4x5 (98x120)	5x7 (123x170)
45°	43mm	66mm	82mm	143mm	203mm
43°36'	**45**	70	86	**150**	212.5
42°	47	72	**90**	156	222
40°	49	**75**	94	164	232
39°36'	**50**	76	96	167	236
36°	**55**	84	**105**	183	259
31°	63	96	121	**210**	297.5
30°44'	65.5	100	125	218	309
30°	68.7	**105**	131	229	324
28°	72	110	138	**240**	340
26°	78	119	**150**	261	370
24°	**85**	130	163	283	401
23°	88	**135**	169	295	417
22°37'	**90**	137.5	172.5	**300**	425
22°	94	143	**180**	313	443
20°24'	100	153	192	333	472
19°26'	**105**	160	201	350	496
19°	108	165	207	**360**	510
17°22'	118	**180**	225	393	556
16°	130	199	**250**	435	616
15°	**135**	206	259	450	637.5
14°	**150**	229	287	**500**	708
13°6'	156.5	239	**300**	521	739
12°32'	163	**250**	314	545	773
12°	**180**	275	335	**600**	850
10°	**200**	306	383	667	944
9°50'	209	319	400	696	985
9°	229	**350**	439	763	1081
8°14'	**250**	382	479	833	1180
6°52'	**300**	458	**575**	**1000**	1417
6°40'	313	478	**600**	1043	1478
6°18'	327	**500**	627	1090	1545
5°52'	**350**	534	671	1167	1653
5°8'	**400**	611	766	1333	1889
4°56'	417	637	**800**	1391	1971
4°6'	**500**	763	958	1667	2361
3°56'	521	797	**1000**	1739	2463
3°26'	**600**	916	1150	**2000**	2833
2°34'	**800**	1222	1533	2667	3778
2°4'	**1000**	1527	1917	3333	4722

References

Preface

Ansel Adams, *Basic Photo Series* (5 volumes), Morgan & Morgan, 1965, 1968, 1970.

Minor White, *Zone System Manual,* Morgan & Morgan, 1963.

Minor White, Richard Zakia and Peter Lorenz, *The New Zone System Manual,* Morgan & Morgan, 1976.

John J. Dowdell III and Richard Zakia, *Zone Systemizer,* Morgan & Morgan, 1973.

Fred Picker, *Zone VI Workshop,* American Photographic Book Publishing Co., Inc., 1977.

Glen Fishback, *The Glen Fishback Exposure System,* Glen Fishback School of Photography, 1963.

Chapter 1

Kodak B/W Photographic Papers, Kodak Professional Data Book G-1, Eastman Kodak Co., 1973.

Alan Horder, ed., *The Ilford Manual of Photography,* 5th ed., Ilford Ltd., 1958.

Chapter 2

James O. Milmoe, *Guide to Good Exposure,* Honeywell, Inc., 1966.

J.F. Dunn and G.L. Wakefield, *Exposure Manual,* 3rd ed., Fountain Press, 1974.

Chapter 3

Leslie Stroebel, *View Camera Technique,* 2nd ed. rev., Hasting House, 1972.

C.B. Neblette and Allen E. Murray, *Photographic Lenses,* Morgan & Morgan, 1973.

William H. Price, "The Photographic Lens," *Scientific American* Vol. 235 Number 2 (August 1976): 72–83.

Understanding Graininess and Granularity, Publication F-20, Eastman Kodak Co., 1973.

H.N. Todd & R.D. Zakia, *Photographic Sensitometry*, 2nd ed., Morgan & Morgan, Dobbs Ferry, N.Y., 1974.

Push-Processing Kodak Black and White Films, Kodak Customer Service Pamphlet AJ-30, Eastman Kodak Co., 1969.

Chapter 10	L.E. Kenneth Mees, Editor, *The Theory of the Photographic Process*, First edition, The Macmillan Company, 1942; second edition, 1954; third edition, T.H. James, Editor, 1966. *Viewing Conditions for the Appraisal of Color Quality and Color Uniformity in the Graphic Arts Industry*. American National Standards Institute, New York, New York. *PSA Constitution and By-Laws*. Photographic Society of America, Philadelphia, Pa. PSA Uniform Practice No. 6. *Lighting of Photographic Color Prints for Judging*. Photographic Society of America, Philadelphia, Pa. *I.E.S. Lighting Handbook*, fourth edition. Illuminating Engineering Society, New York, N.Y.
Chapter 11	Eastman Kodak Co., *Basic Photographic Sensitometry Workbook*, Kodak Publication No. Z-22-ED, 1971. Yule, J., *Principles of Color Reproduction*, John Wiley & Sons, Inc., New York, New York 1967.

Glossary

On the following pages are some of the terms most relevant to Photographic Tone Control. For a more comprehensive list of definitions, the reader is referred to the illustrated *Dictionary of Contemporary Photography,* by L. Stroebel & H. N. Todd; Morgan & Morgan, Publishers, Dobbs Ferry, New York. Copyright 1974. The terms listed here are quoted directly from that dictionary. Where terms are given several definitions in the dictionary, only the ones appropriate to this text have been selected for quotation.

agitation	In chemical processing, the action that causes a flow of processing solution with respect to the photographic material. The intent is to assure sufficiently uniform chemical activity by replacement of spent solution with fresh.
American National Standards Institute (ANSI)	New (1970) name for the organization previously known as the United States of America Standards Institute (USASI), which before that was known as the American Standards Association (ASA). A largely voluntary organization of persons devoted to the development and publication of detailed methods of procedure and measurement in a variety of fields, including photographic testing.
angle of acceptance	As applied to luminance (commonly called reflectance) light meters, the number of degrees within which the meter effectively receives and responds to light. Spot meters receive light over only a few degrees, whereas the angle of acceptance of conventional light meters roughly approximates the angle of view of cameras equipped with normal lenses: approximately 30 to 50 degrees.
aperture	In optical systems, the diameter of an opening in a plate that otherwise obstructs radiation. In the case of a noncircular opening, the diameter of a circular opening with the same area.
ASA speed	For photographic materials, a numerical value used for determining camera or printer settings. The value is determined by methods specified in ANSI published standards: for black-and-white negative materials (pictorial), PH2.5-1972; for black-and-white photographic papers, PH2.2-1966.

base	Sheet-like material used to support one or more photosensitive layers as in photographic film, paper, and plates.
base plus fog	The optical density of an unexposed area of processed film or paper.
bellows factor	A number obtained by dividing the square of the image distance by the square of the focal length, used to compensate for the decrease in image illuminance as the camera is focused on closer objects and the lens-to-film distance increases. The factor represents the required increase in exposure, which can be obtained by changing the exposure time and /or the aperture. Also called bellows-extension compensation.
brightness	The subjective aspect of visual perception that is approximately correlated with the luminance of objects seen as light sources. Since brightness is a psychological concept, there are no units of measurement. The term "photometric brightness" should be replaced by "luminance."
bromide streak	A region of lowered density in areas of a processed image adjacent to high-density areas. The cause is a flow of partially exhausted developer over the material during processing, in situations in which the agitation is inadequate. Syn.: bromide drag.
burned-out	Applied to an image area that lacks detail as a result of excessive exposure—typically a highlight area of a subject illuminated with a high lighting ratio.
burn in	To give selected areas of an image, typically an enlargement, additional exposure so as to alter the density locally. Distinguish from dodging (giving less exposure locally).
calculated midtone	Identifying a method of using an exposure (light) meter in which two luminance (reflection-type) readings are taken, one from the lightest area where detail is desired and one from the darkest. A position halfway between the two readings is used in selecting the combination of f-number and shutter speed. Syn.: luminance-range.
camera flare	Non-image-forming light in a camera, caused by the reflection of light from interior surfaces of the camera, and resulting in an increase in illuminance and a decrease in contrast of the image.
chemical fog	Density in processed silver halide photographic materials that is not attributable to the action of radiant energy. Chemical fog may be caused by the action of a developing agent, by oxygen (as when a film wet with developer is exposed to air), or by the action of chemical contaminants. Chemical fog occurs in both unexposed and exposed areas of the film, but tends to decrease as the exposure increases. Thus its deleterious effects are greatest in the low-density areas of the image, where it causes a reduction in detail and contrast.

chroma	An attribute of color that varies with the saturation of hue, e.g., the extent to which a red pigment departs from gray pigment of equal value (lightness). With the Munsell system of color notation, gray is numbered 0 and the numbers 1, 2, 3, etc., indicate equal increments in saturation of a hue, i.e., chroma.
close down	To change the f-number setting on a lens to a selected f-number that represents a smaller diaphragm opening. To change the f-number setting from f/8 to f/11, for example, would be to close down one stop. Syn.: stop down.
color filter	A layer of transparent material that reduces to different degrees the energy in different portions of the visible spectrum. Used for any of various purposes, including lightening or darkening selected subject colors in black-and-white photographs. One of three major classes of optical filters, the others being neutral-density and polarizing.
color sensitivity	A measure of the response of a photographic material to a narrow band of radiation from the visible part of the spectrum. The term "spectral sensitivity" is generally preferred, especially when ultraviolet, infrared, or other invisible radiation is involved.
color temperature	A scale for rating the color quality of illumination. The color temperature of illumination being calibrated is the actual temperature in degrees Kelvin (K) of a "blackbody" heated to a temperature that produces a visual color match. That two sources have the same color temperature by no means implies that they are equivalent photographically or physically.
contrast	The actual (objective) or the perceived (subjective) variation between two or more parts of an object or image with respect to any of various attributes such as luminance, color, or size. Subjective contrast is commonly described in general or relative terms (e.g., high contrast, lower-than-normal contrast). Examples of objective contrast: (a) as applied to a scene, the ratio of highlight to shadow luminance (e.g., 160 to 1, or a log interval of about 2.2); (b) as applied to a photographic negative material, the maximum possible gamma, or contrast index; (c) as applied to a specific negative, the density difference between highlight and shadow areas (e.g., $1.0 - 0.3 = 0.7$); (d) as applied to photographic paper material, contrast is inversely related to exposure scale, and very roughly related to paper-grade number; e.g., a zero-grade paper has a large exposure scale (1.70) and a 5-grade paper has a small exposure scale (0.70).
contrast grades	Numbers applied to photographic printing papers as an indication (in inverse order) of their exposure scales (scale indexes). The numbers are consecutive integers, with 0 representing a high exposure scale (about 1.70) and 5 representing a low exposure scale (about 0.70). The hypothetically correct contrast grade of paper for a given negative can be selected by relating the density scale of the negative to the paper exposure scales.

covering power	(optical) The extent to which a lens is capable of forming a usable image off the lens axis, expressed variously as the maximum film size that can be used with the lens, the diameter of the circle of good definition, or the angle of coverage.
dark slide	An opaque panel which seals a film holder to light but which can be removed after the holder has been attached to a camera, thereby allowing the film to be exposed.
densitometer	An instrument used to measure the light-absorbing ability (density) of a photographic image. Densitometers may be visual (in which case the eye compares the appearance of the sample with that of a calibrated reference) or photoelectric (in which case a photocell measures the light transmitted by or reflected from the sample as compared with that light recorded when no sample is present). Densitometers are often equipped with filters, etc., to measure the density of the sample for selected wavelength bands of radiation.
density (D)	A logarithmic measure of the light-absorbing characteristics of an image, filter, etc. Density is defined as the logarithm of the ratio of the light falling on and transmitted by the sample (or reflected by the sample, in the case of prints, etc.).
density scale	A measure of the tonal range of a photographic image, obtained by subtracting the minimum density from the maximum density. For negatives, density scale is the same as total contrast.
developer streaks	(1) Generally, nonuniformity within a uniformly exposed region, caused by a flow of developer from adjacent areas of the image. A sign of inadequate agitation. (2) Specifically, regions of higher density in areas of a processed image adjacent to low-density areas. The cause is a supply of stronger (less exhausted) developer than is available to similarly exposed regions that are adjacent to higher-density areas. Contrast with bromide streaks.
development contrast	The relationship between the density produced in two or more parts of a photographic image as affected by factors such as developer composition, time and temperature of development, and agitation. Contrast index and gamma are measures of development contrast. Development contrast is distinct from the contrast associated with subject reflectance, lighting, exposure, etc.
DIN	(1) Deutsche Industrie Norm. A standard established by the German counterpart of ANSI; i.e., Deutschen Normenausschuss (DNA). (2) A method for determining the speed of photographic materials based on a small constant density (0.1) above the base-plus-fog density, and using logarithmic units.

dodge	To reduce the exposure in selected areas of an image to alter the density, e.g., by holding an opaque object between the lens and the easel in projection printing, or by turning one or more lights off in a multiple-light contact printer. Compare with burn in (adding exposure to part of an image). Syn.: hold back.
effective aperture	The diameter of an entering collimated (parallel) beam of light that will just fill the opening in the diaphragm in an optical system such as a camera lens. The effective aperture is the same in size as the diaphragm opening (or aperture) only when the diaphragm is located in front of the lens. Syn.: entrance pupil.
effective exposure time	The time duration between the half-open position and the half-closed position of a leaf-type shutter. In this context, the shutter is considered to be "open" when any specified diaphragm opening is just completely uncovered, whereas the marked shutter speed is based on the maximum diaphragm opening. Therefore, the effective and marked shutter speeds (on a perfectly calibrated shutter) agree only when the diaphragm is set at the maximum opening. With the diaphragm stopped down, the film receives more exposure than is indicated by the marked shutter speed.
emulsion	A dispersion of silver halide crystals in gelatin or other suitable material. Preferred term: photographic emulsion.
exhaustion	A condition of deterioration in a material resulting from use, aging, contamination, etc., whereby the intended function can no longer be performed. Commonly applied to processing solutions.
exposure index (EI)	A number intended to be used with an exposure meter to determine the camera settings that will produce an image of satisfactory quality. For a given material, exposure indexes may vary with the subject and the desired effect, whereas film speeds are determined in a standard way, usually sensitometrically.
exposure meter	A light-measuring instrument designed to provide appropriate time and aperture settings on a camera for a desired exposure effect. (Note: Strictly, such meters measure light only if their response equals that of the human eye in color response. Further, such meters do not measure exposure in the sensitometric sense; they measure luminance or illuminance, depending upon their acceptance angle and calibration.)
fill light (fill-in)	A light source or a reflector used to illuminate the shadows created by the main light, thereby reducing the lighting ratio.

filter factor

A multiplying number used to compensate for the absorption of radiant energy (light) by a filter. Specifically, the exposure time is multiplied by the number when a filter is added, or an equivalent change is made in the relative aperture. The intent is to reproduce neutral (gray) tones in the image in the same way with as without the filter. Since there is sometimes a contrast change in the image, a fixed density value is often used, such as 0.6. The value of the filter factor will vary with the quality (color) of the light source, the type of film and the development conditions, among other factors.

flare

Non-image-forming light in a camera or other optical system due to the reflection of light from lens surfaces, interior surfaces of the mechanism, etc., causing an overall or local decrease in contrast and increase in illuminance of the image. The effect of flare is most noticeable with backlighted subjects.

f-number

A number (f/16, for example) obtained by dividing the focal length of a lens by the effective aperture, used to control the amount of light transmitted by a lens. (The image illuminance is inversely proportional to the square of the f-number. The required exposure time is directly proportional to the square of the f-number.) Selected f-numbers, usually representing the maximum aperture and consecutive whole stops, are normally printed on the lens mount, Syn.: relative aperture.

focal length

The distance from the best axial focus of an infinitely distant object to the rear nodal point of a lens. Preferred term: equivalent focal length.

fog

Density in processed photosensitive materials that is not attributable to the action of image-forming radiant energy. The two major types are light fog and chemical fog.

full stop

A change in an aperture that corresponds to multiplying or dividing the lens transmittance by 2 or the f-number by the square root of 2. Consecutive f-numbers in the conventional series represent full stops, for example, f/8, f/11, f/16.

graininess

Nonuniformity of density in a presumably uniformly exposed and processed area of a photographic image as perceived by a viewer. A measure of graininess is the magnification at which the nonuniformity just disappears. Graininess is a subjective property that corresponds with granularity, an objective property.

gray card

A neutral-color cardboard, typically having 18% reflectance, used as a standard artificial medium tone for luminance (reflection-type exposure meter) readings. In the Munsell system of color notation, middle value 5 has a reflectance of approximately 18%.

gray scale	A series of neutral tones arranged in sequence from light to dark, usually in discrete calibrated steps, ideally with equal density differences between steps. Transmission (as distinct from reflection) gray scales are also known as step tablets and "step wedges."
high-contrast	Applied to a lighting, developer, printing paper, film, etc., used to increase differentiation of tones, either to achieve a desired contrasty effect or to compensate for a low-contrast influence elsewhere in the process.
highlight	(1) Any subject area illuminated by the main light source or a corresponding area on an image. A strong reflection from a shiny surface is differentiated as a specular highlight. (2) Loosely applied to any light-tone area on a subject or a positive image, or a corresponding dense area on a negative image.
hue	An attribute of color that varies with the wavelength composition of the light and is associated with names such as red, green, blue, cyan, magenta, yellow, orange, and greenish yellow. The other two attributes of color are saturation (or chroma) and lightness (or brightness, or value).
incident	Identifying energy, especially light, falling on a surface, as contrasted with that reflected, transmitted, or emitted by a surface. An incident light meter estimates the illuminance on a surface of interest, such as a part of a scene or an exposure plane.
intermittency effect	The change in response of a photographic material associated with an exposure divided into portions, as compared with the response associated with a single continuous exposure of the same magnitude.
K (formerly, k°)	Kelvin. A temperature scale based on absolute zero, and used for the specification of the color of some light sources. See color temperature.
lens flare	Light, reflected and re-reflected from air-glass surfaces, that finally falls on the image plane. The effect in the camera is a reduction in contrast of the dark (shadow) areas. In printing, a similar deterioration occurs in the highlight areas. Lens coating reduces lens flare and for this reason improves image quality.
low contrast	(1) In a subject, little difference between tones; i.e., a small ratio of subject luminances. (2) In a negative, little density difference; soft; flat. (3) In a print, with less than normal tonal difference, usually because of the absence of light highlights and dark shadows.
luminance-range	Identifying a method of using an exposure (light) meter in which two luminance (reflection-type) readings are taken: one from the lightest area in which detail is desired, and one from the darkest.

midtones	In a scene or photographic image, areas intermediate in lightness or brightness between highlights and shadows. Grays, as distinguished from whites and blacks.
mottle	A defect in an image appearing as nonuniformity of density. Mottle can be avoided by proper agitation during processing, and by full development.
negative	A photographic image in which light subject tones are reproduced as dark (dense) and dark tones as light (thin).
neutral density filter	A partially transparent sheet of glass, gelatin, plastic, etc., that absorbs approximately the same fraction of any wavelength of light.
neutral test card	A panel, usually with an 18%-reflectance gray surface on one side and a 90%-reflectance white surface on the other. Such a card is useful as a standard object for light measurement in estimating the required camera settings, and also for checking color balance in color images. Syn.: gray card.
oxidation	Loss of activity of a photographic developer caused by chemical action, especially associated with exposure to aerial oxygen.
parallax	The apparent shift in relative position of an object when it is viewed from different positions. Since a viewfinder is often in a different position than the camera lens, because of parallax the image as seen through the viewfinder is different from the image recorded by the camera lens.
pushing	The process of attempting to increase effective film speed by increasing the degree of development (time, temperature, developer activity). The effect is not ordinarily equivalent to that produced by an increased exposure level. Pushed negative images usually have exaggerated contrast in the highlights, insufficient detail in the shadows, and increased graininess. With color films, a shift in color balance may also result.
reciprocity law (failure)	The law is a statement that the photographic response (usually density) will be constant if the quantity of light received by the photosensitive material is constant, regardless of the rate at which the energy is supplied. In practice, the reciprocity law implies that the density of the image will be the same at a camera setting of 1/1000 second at f/2 as at 1 second at f/64. The law does not hold in general for the developed image made by exposure to light; hence the term "reciprocity-law failure" (RLF). The practical consequence is that adjustments in camera settings and often development time need to be made whenever exposure times are unusually small or large, the adjustments being best determined by experiment.

reflected-light (exposure) meter Preferred term: luminance meter. A light-measuring instrument with a restricted angle of acceptance. The reading is proportional to the luminance (intensity per unit area) of the source of light, whether it emits or reflects light. A spot meter is a luminance meter with a very narrow angle of acceptance. See exposure meter.

sharpness That subjective quality of an image associated with the distinctness of boundaries between adjacent objects. Sharpness can be measured by asking a group of observers to rank images with respect to this quality.

shutter speed (1) The effective exposure time produced by a shutter, usually defined as the time interval between the half-open and half-closed positions of the shutter. Distinguish from total operating time and from fully-open time. In focal-plane shutters, the speed is controlled by varrying the width of the slit and/or the speed with which it travels. (2) The marked exposure time on a shutter, which may differ significantly from the actual exposure time, caused by inaccuracy or by a change in the effective exposure time as the lens aperture is changed.

spot meter A luminance meter ("reflection"-type "exposure" meter) with a very narrow angle of acceptance so that it can measure a small subject area at a considerable distance. Most spot meters are photoelectric, but some are of the comparator type.

step tablet A device for testing a photographic material, consisting of a set of patches having different absorptions of light. When a sample of photographic material is exposed to such an object, the sample receives different intensities of light (illuminances) and thus different exposures. Also known as step wedge, but step tablet is the preferred term.

stop down To reduce the aperture of a lens. The converse of open up. Syn.: close down

subject contrast The ratio of luminance values from highlight to shadow in a scene. The average value for outdoor scenes is 160-1.

tone control Any method of altering image densities to produce a desired effect. Some or all of the following may be used: a change in the exposure level of the original record or of the print, etc.; a change in development conditions (time, bath composition, etc.); the use of an intermediate positive or negative; masking.

variable-contrast In a print material on a paper base, the use of two superimposed or mixed emulsions that differ in spectral sensitivity (response to different wavelengths of light) and also in scale index (contrast). Different print-contrast characteristics can be obtained by the use of different colors of light in exposing the material, as by the use of filters. In this way, different paper grades can be obtained from a single material.